CW00742426

URBAN
GEOMETRY

URBAN GEOMETRY

ANDRÉS GALLARDO
ALBAJAR

HOXTON MINI PRESS

ANDRÉS GALLARDO ALBAJAR

Andrés is a freelance architecture and urban photographer from Spain. Despite being the son of architects, it wasn't until he got his first DSLR camera in 2012 that he developed an interest in architecture and built environments. For years Andrés has been documenting the architecture and urban life of numerous European and Asian cities, and his work has been featured in many publications and exhibitions.

HOXTON MINI PRESS

Hoxton Mini Press is a small independent publisher based in east London. We make photography books about cities, often London, and always with a focus on niche, human stories. We believe that books are something to collect, own and inspire, and that as the world becomes evermore virtual beautiful books should be cherished and kept stacked neatly on wooden shelves.

INTRODUCTION

It looks like something that has landed from the future. A fluid structure that not so long ago would have been impossible, achievable now thanks to a revolution in computer aided design, and to the audacious imagination of its architect, Zaha Hadid. 'It is like a pianist constantly practicing – it's the same level of intensity,' said Hadid, describing her creative process in a 2015 interview with *Designboom*. Here is that intensity realised, a seamless swirl of curves, no corners to be seen – a symphony in concrete, aluminum, glass, and stainless steel.

Completed in 2012, Hadid's Galaxy SOHO is a 330,000-square-metre retail, office and entertainment complex in Beijing. In many ways it is symbolic of the kind of visionary, high-tech architecture that has reshaped our cityscapes over the past 20 years, a golden age, shaped by that sometimes controversial figure of the 'starchitect', during which ever more breathtaking, gravity-defying buildings has become the way that cities project an image of themselves as modern, international, desirable places to be.

Galaxy SOHO is the first building we see in *Urban Geometry*, which features some of our most iconic contemporary architecture – by Hadid, and other giants of her generation such as Frank Gehry, Norman Foster. Housing blocks to museums, a kindergarten, shopping centres and power stations, the book features neofuturist, deconstructivist and postmodern 21st-century architecture predominantly, but not exclusively, the earliest building being the functionalist Helsinki Olympic Stadium, built in 1938. Reflecting the global nature of architecture today, the images take us from Andrés Gallardo Albajar's

birthplace of Alicante and his adopted home Tallinn in Estonia to Stockholm, Seoul and beyond.

If they play out like a personal travelogue of discovery, that's because that's exactly what they are. A long-term project, *Urban Geometry* has developed organically. Gallardo Albajar is a self-taught photographer, with a professional background in advertising and marketing. Two architects for parents, he grew up immersed in buildings. Gifted a camera for his 30th birthday, he found himself irresistibly drawn to documenting the urban built environment. Before Gallardo Albajar visits a city, he researches the architecture, but once there he rarely takes public transport, instead wandering the streets by foot, getting gloriously lost. This is not a round-up of the most famous architecture to be found in each city. For every culturally game-changing Guggenheim Bilbao or Muralla Roja, the labyrinthine apartment complex built in 1968 by Ricardo Bofill, there are several unnamed buildings by unknown architects that simply caught his eye.

Similarly, rather than present the building in its entirety, in a way that would make it more immediately recognisable, Gallardo Albajar shows us less, and reveals more. He hones in on precisely those details that make these structures so extraordinary. The point at which Tao Zhu Yin Yuan tower twists around, the soaring austere glass walls of the Library of France as seen from below. The Imprint's enticing gold entrance, pulled up, like a curtain, with some invisible string. His photographs speak an abstract language of symmetry, line, curve, colour, a geometric language. Partial views and unusual perspectives give *Urban Geometry* an immersive feel that echoes the embodied, dynamic experience of moving around a city.

'Music is liquid architecture; architecture is frozen music,' said the poet Johann Wolfgang von Goethe. And it's true, starting with the Galaxy SOHO, the shots in *Urban Geometry* seem to rise and fall in their own symphonic flow. Their sometimes minimalist composition reminds us of the shared mathematical roots of both architecture and music. There are some truly spectacular individual examples of architecture celebrated here, but more than that, the series calls on us, wherever we are, to tune into the buildings and urban planning that we might not otherwise notice but nonetheless create the spatial soundtrack to our everyday lives.

Rachel Segal Hamilton

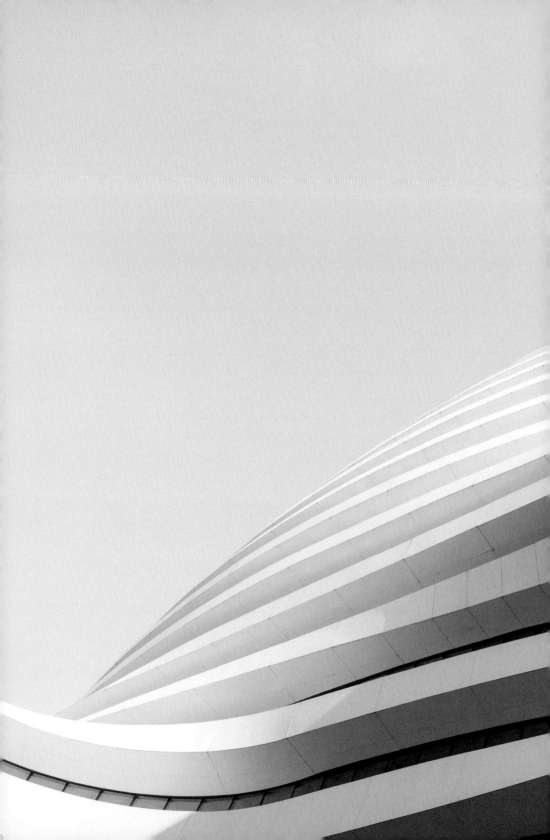

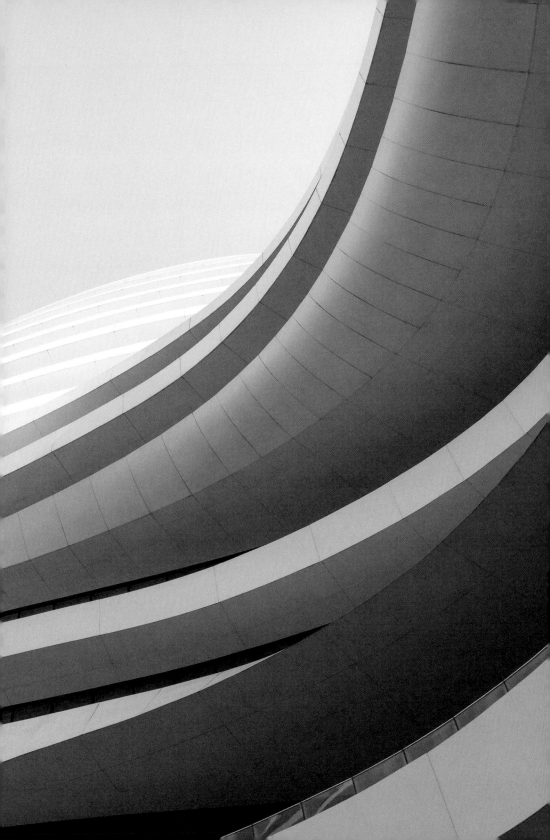

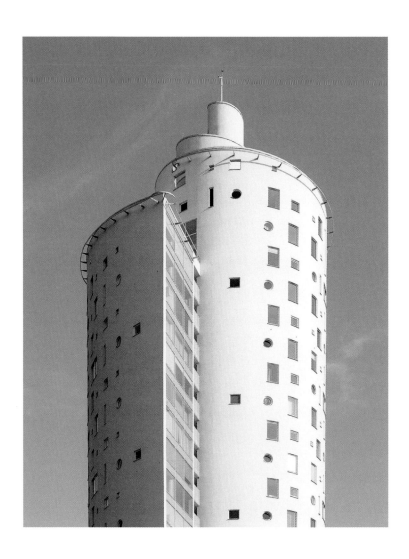

Beijing, China *(previous)*
Tartu, Estonia *(above)*
Seoul, South Korea *(opposite)*

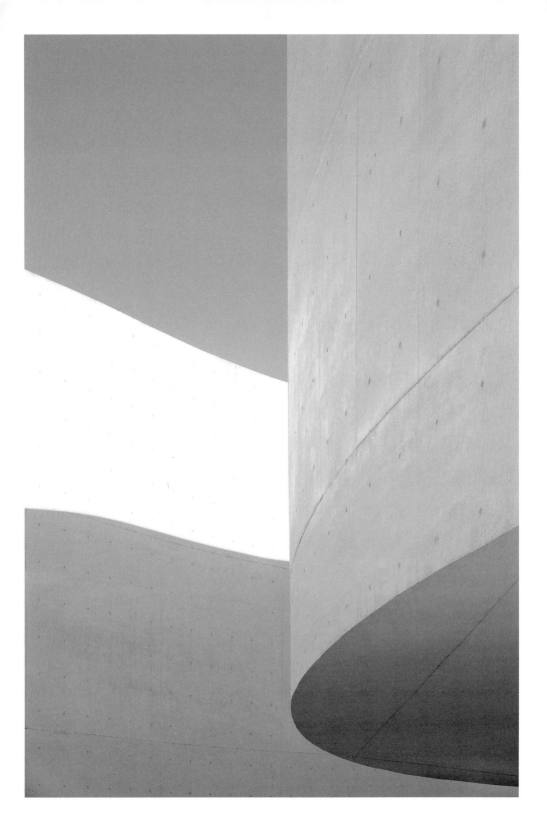

Taichung, Taiwan

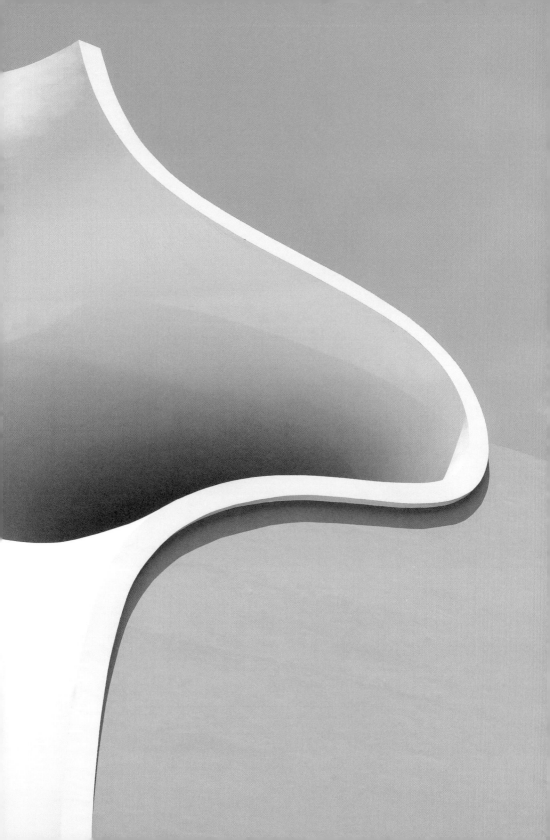

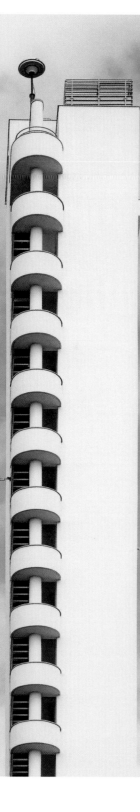

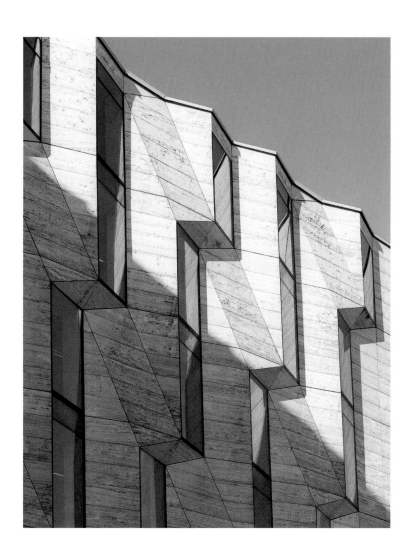

Copenhagen, Denmark *(above)*

Helsinki, Finland *(opposite)*

Tallinn, Estonia *(opposite)*

Seoul, South Korea *(overleaf)*

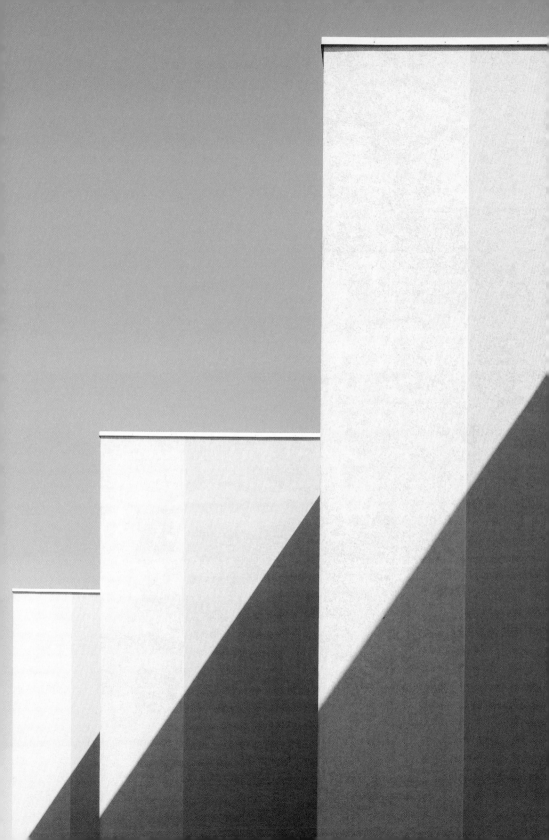

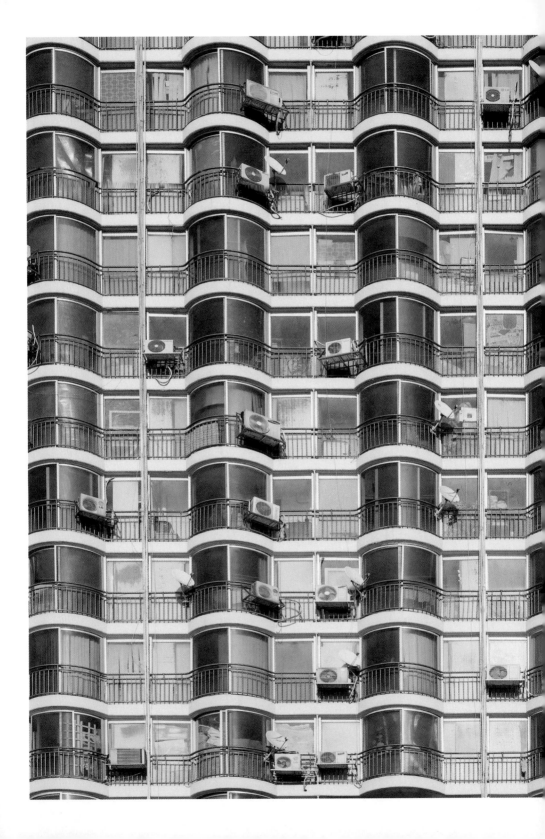

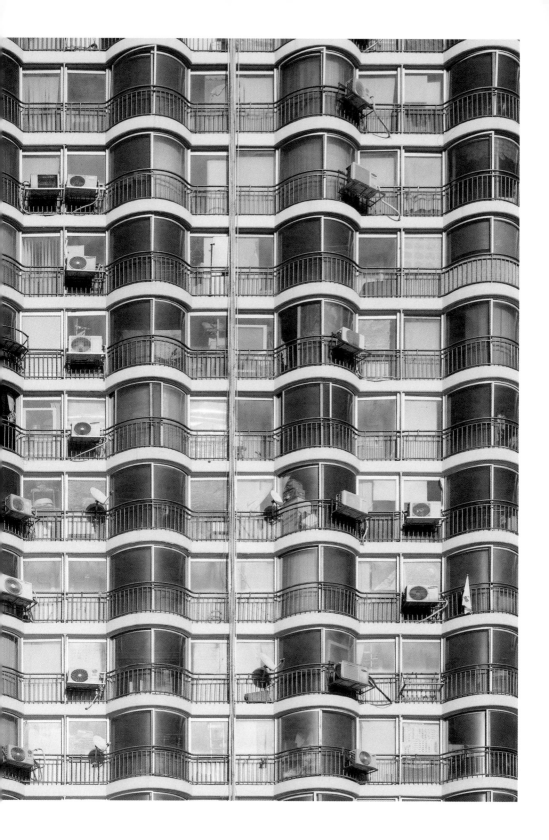

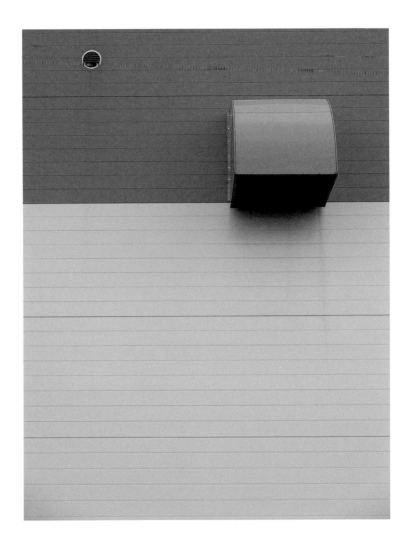

Tartu, Estonia *(above)*
Huesca, Spain *(opposite)*

Milan, Italy *(overleaf)*

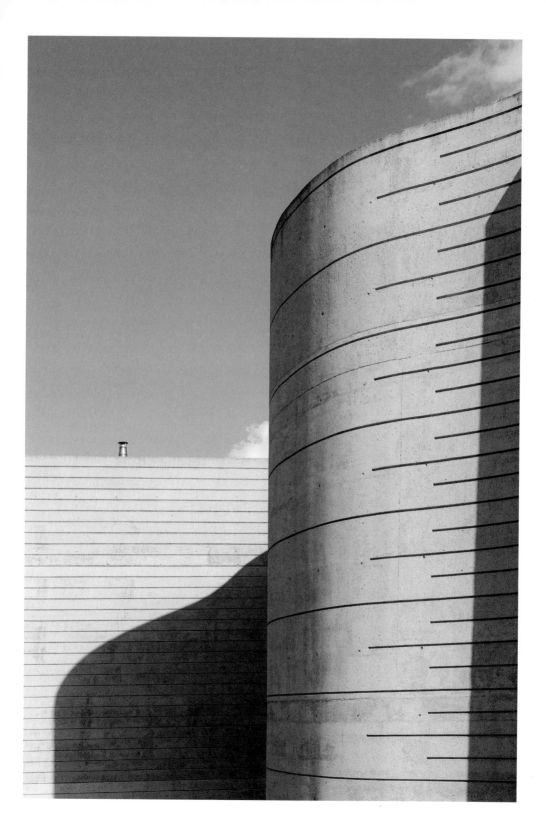

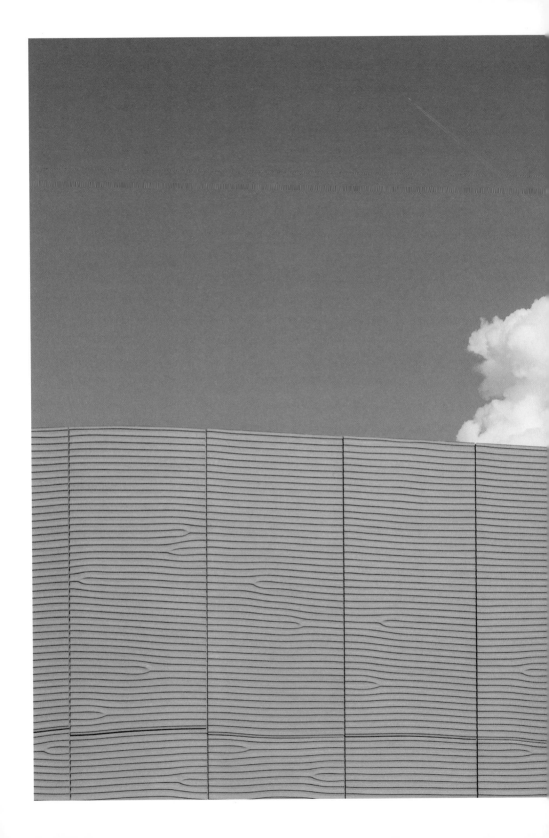

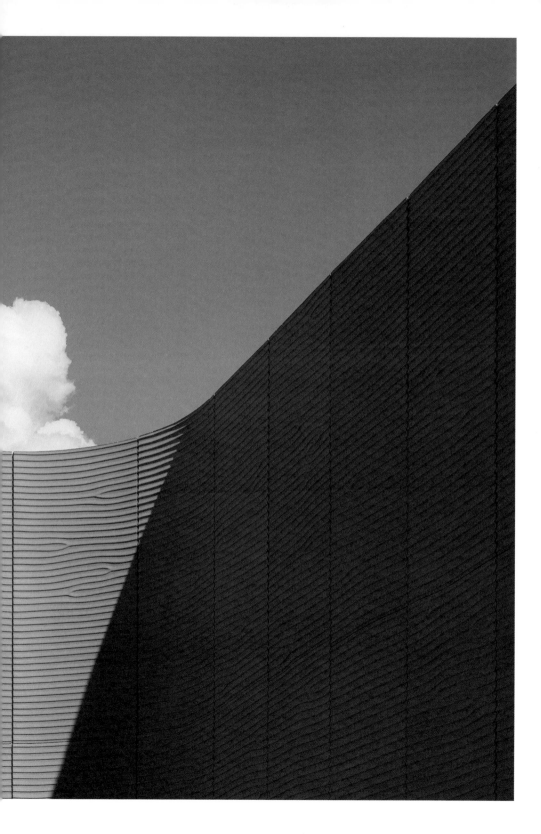

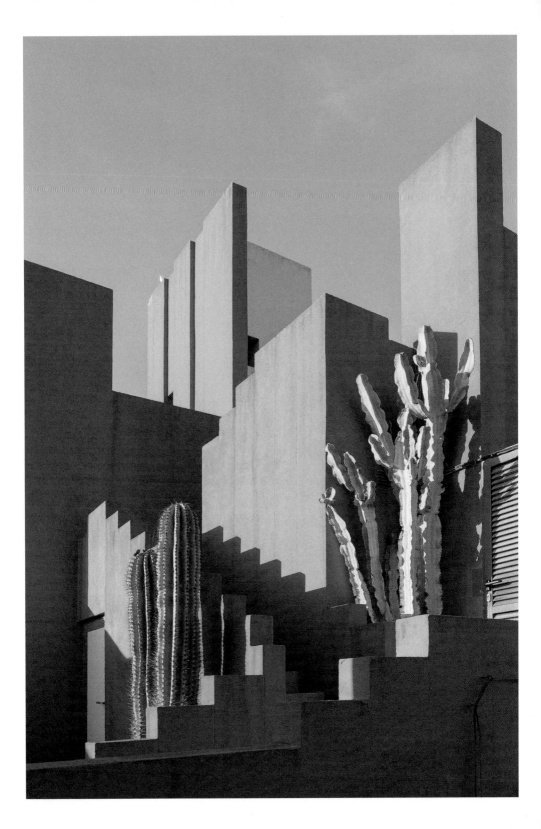

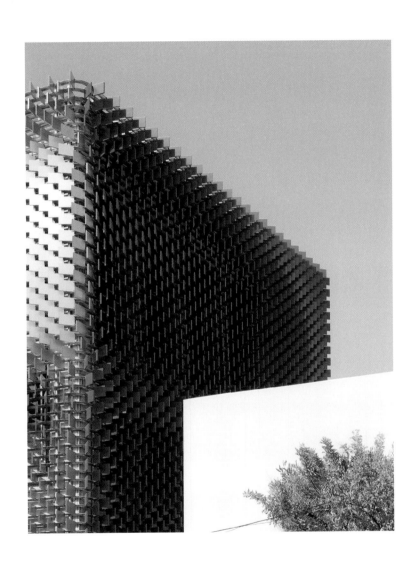

Seoul, South Korea *(above)*
Alicante, Spain *(opposite)*

25 Berlin, Germany *(overleaf)*

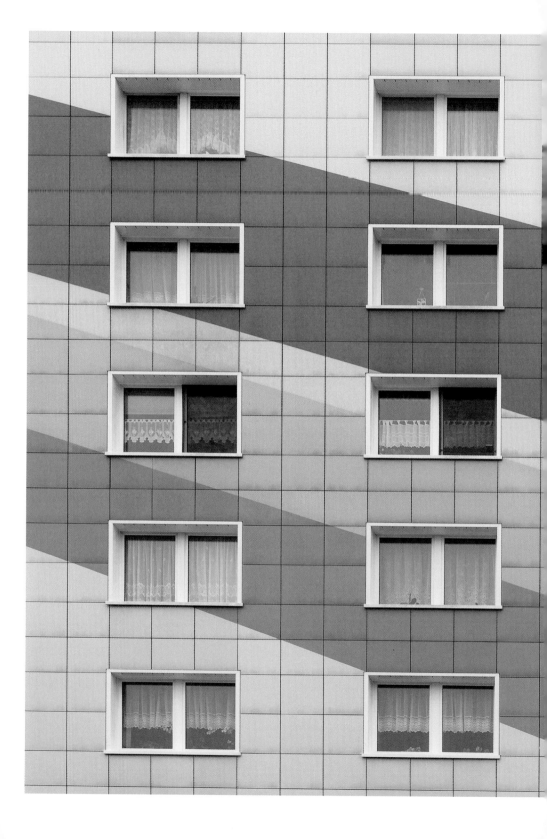

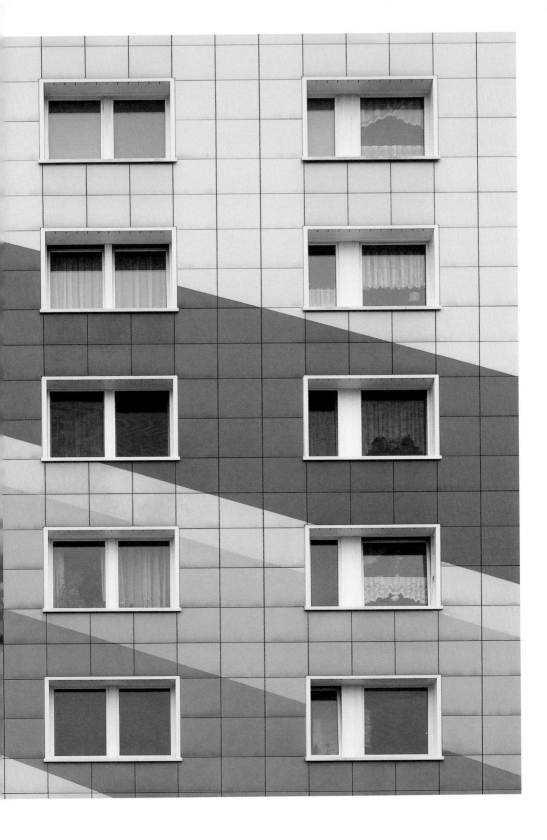

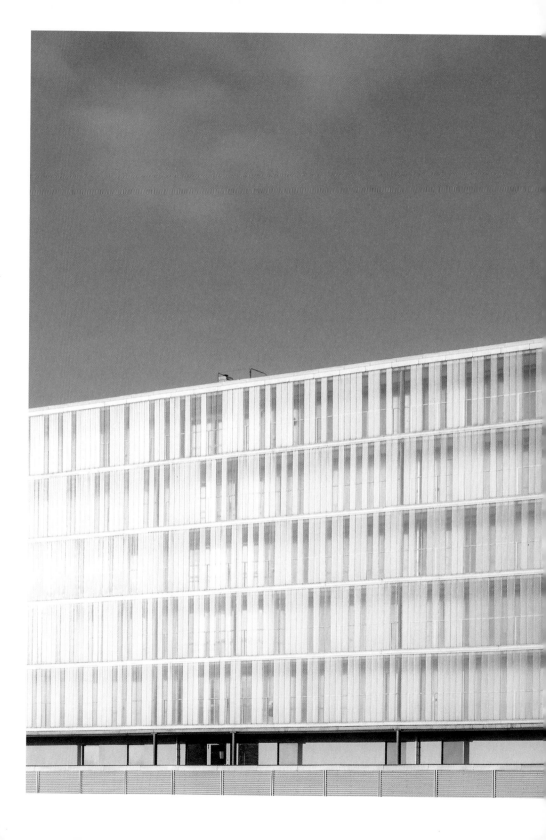

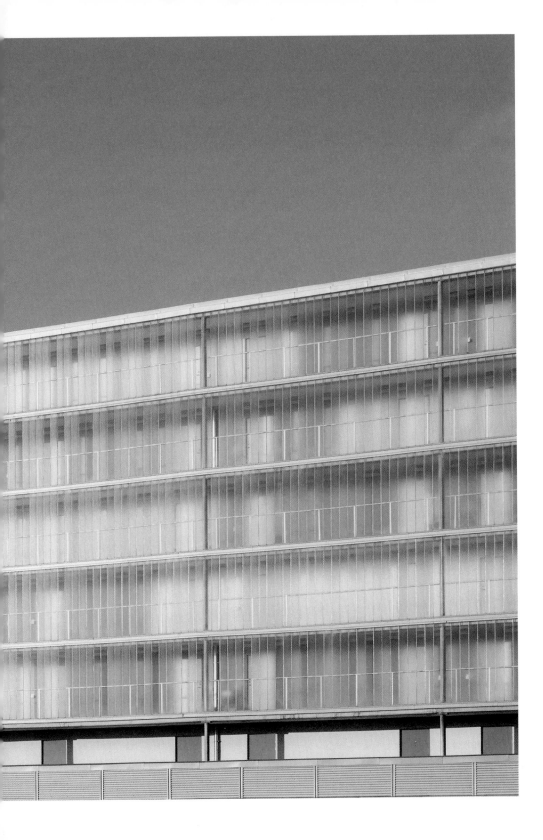

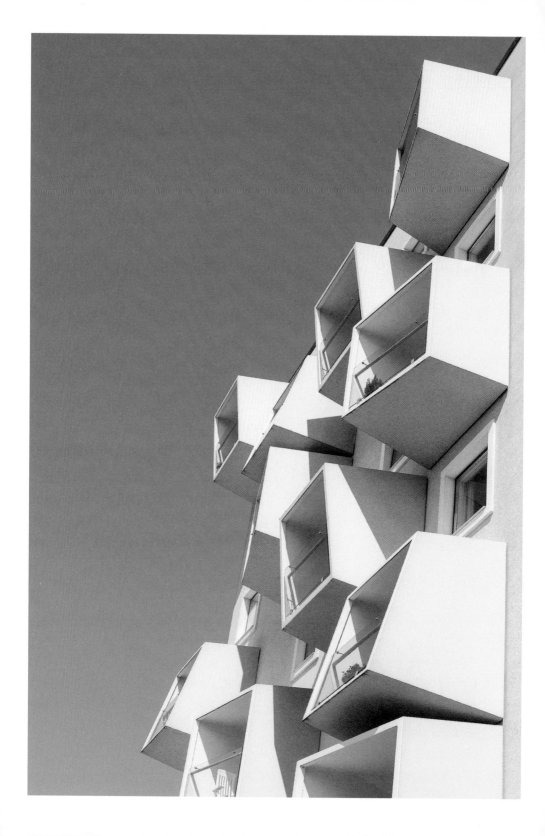

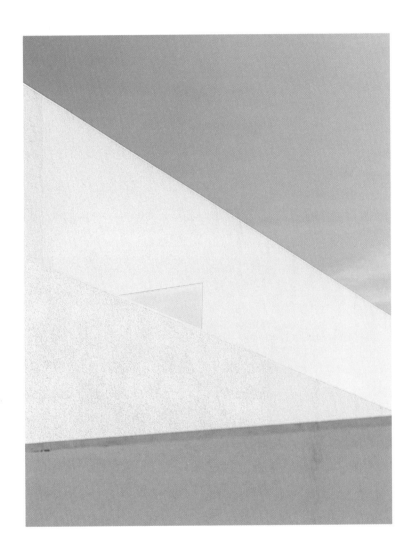

Stockholm, Sweden *(previous)*
Alicante, Spain *(above)*
Copenhagen, Denmark *(opposite)*

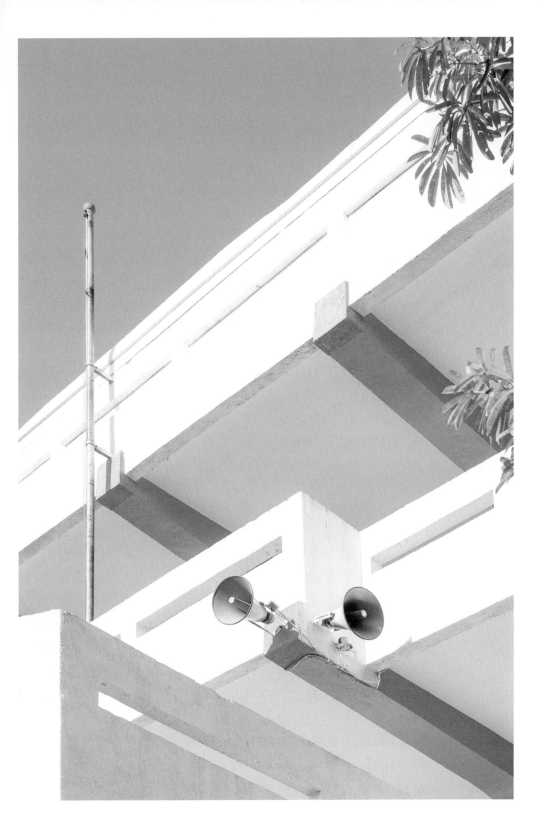

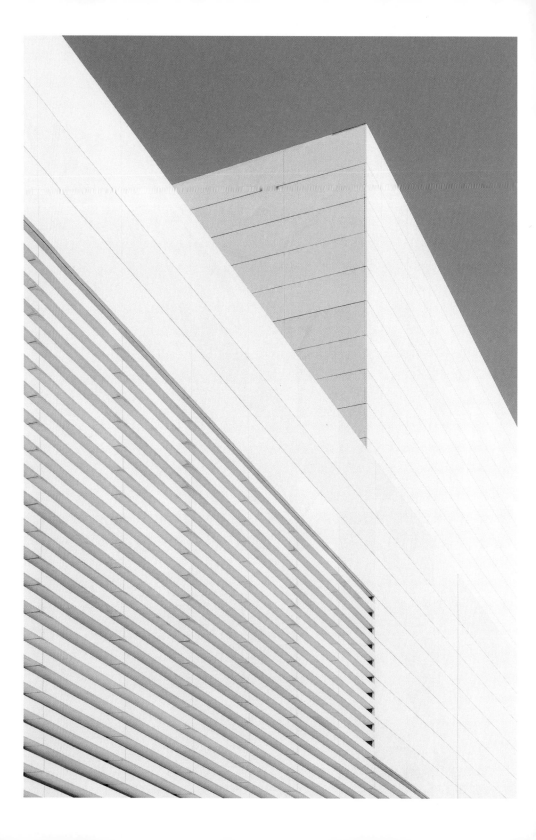

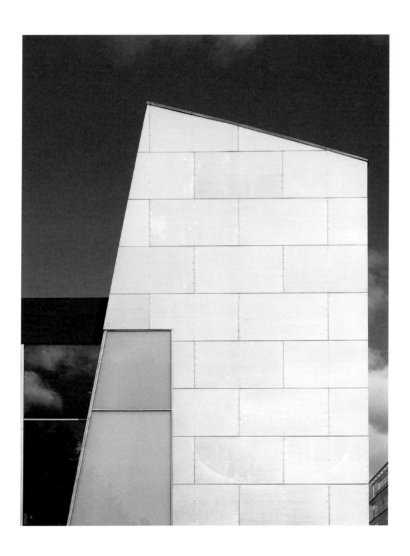

Helsinki, Finland *(above)*

35 Alicante, Spain *(opposite)*

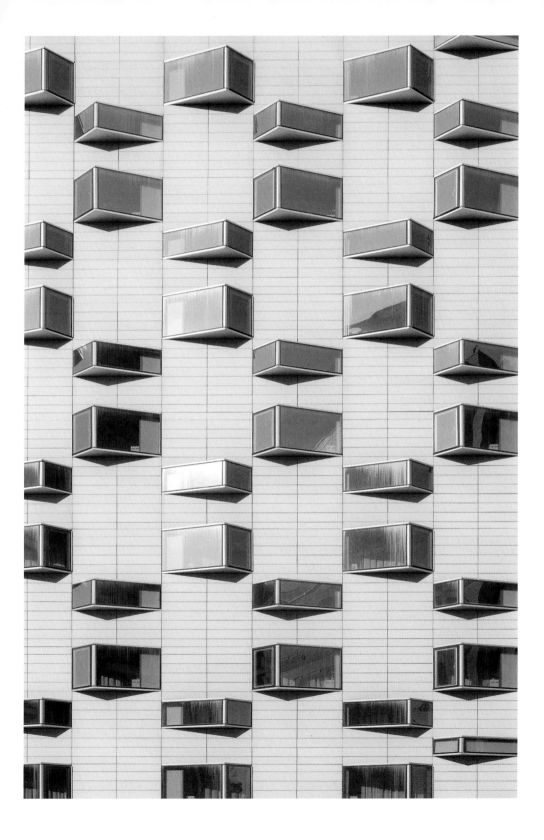

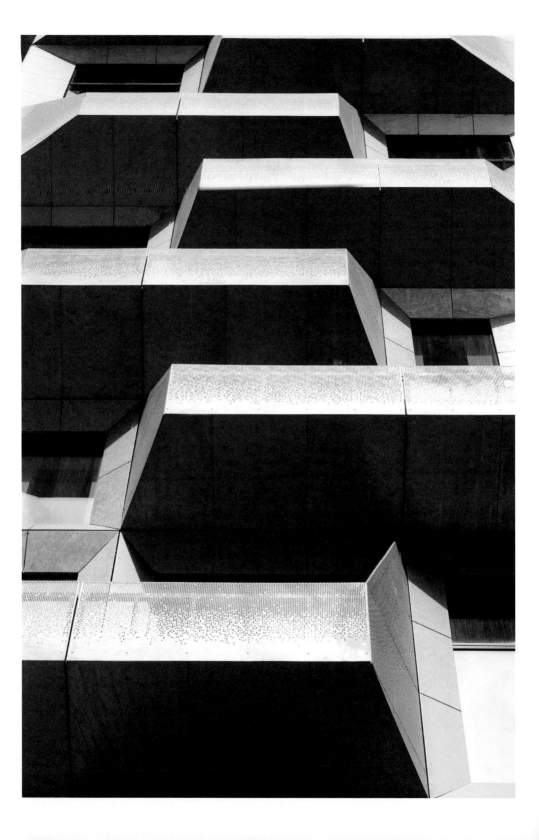

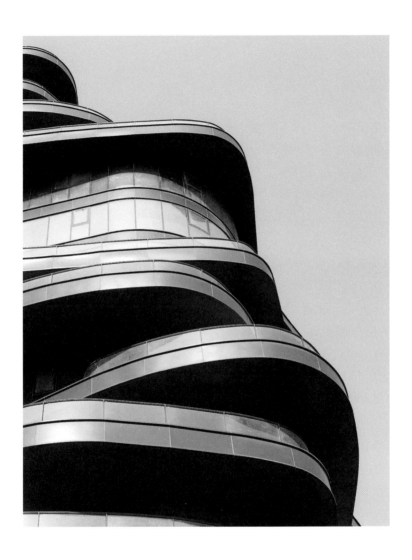

Beijing, China (*above*)
Copenhagen, Denmark (*opposite & overleaf*)

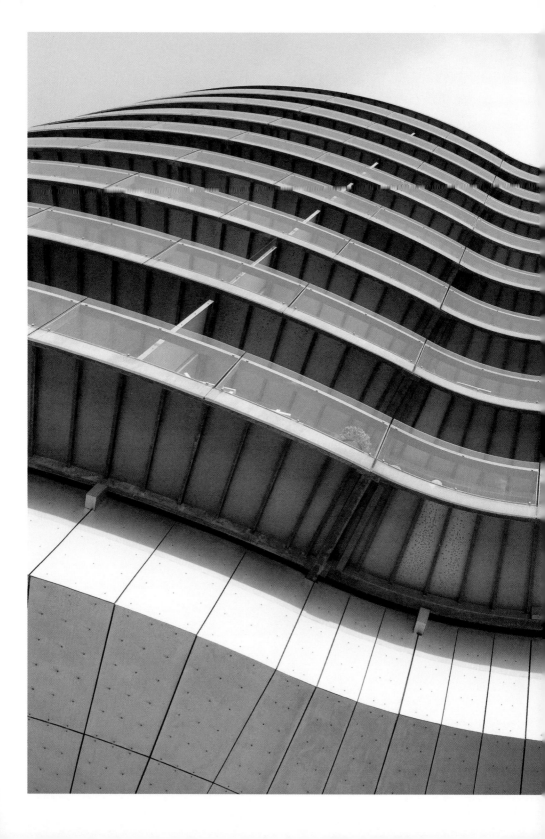

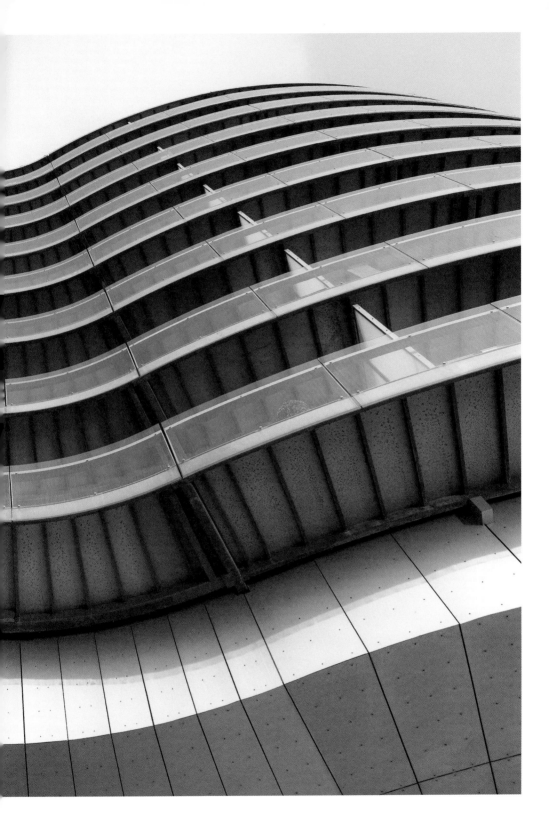

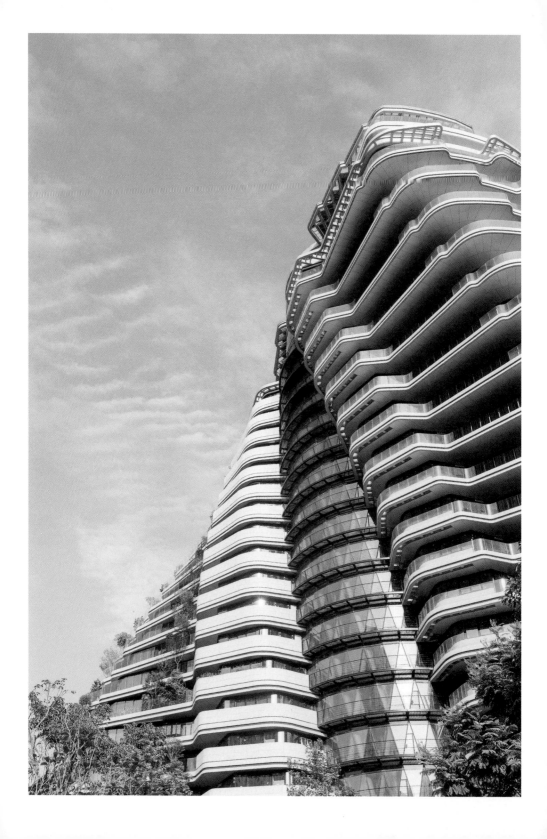

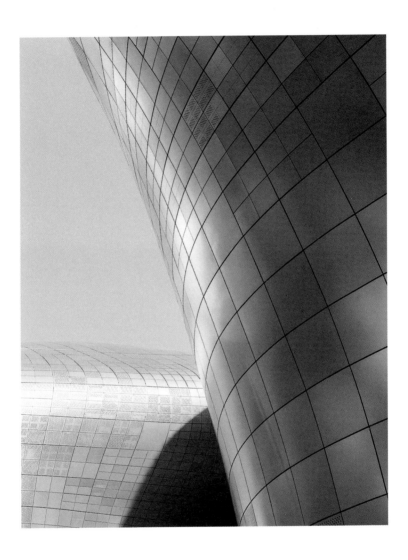

Seoul, South Korea *(above)*
Taipei, Taiwan *(opposite)*

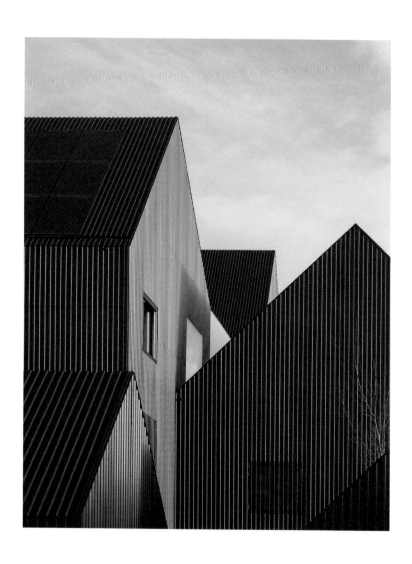

Copenhagen, Denmark *(above)*

44 Alicante, Spain *(opposite)*

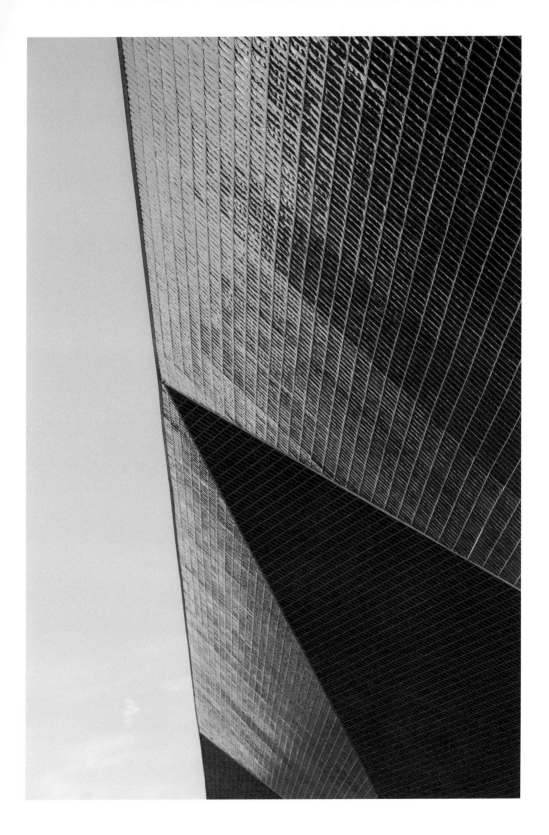

Huesca, Spain *(opposite)*
Paris, France *(overleaf)*

Hamburg, Germany *(subsequent)*

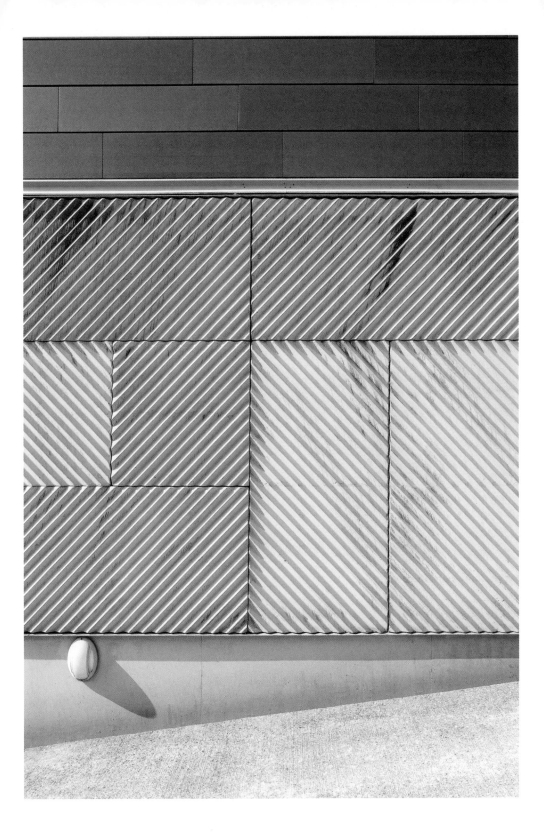

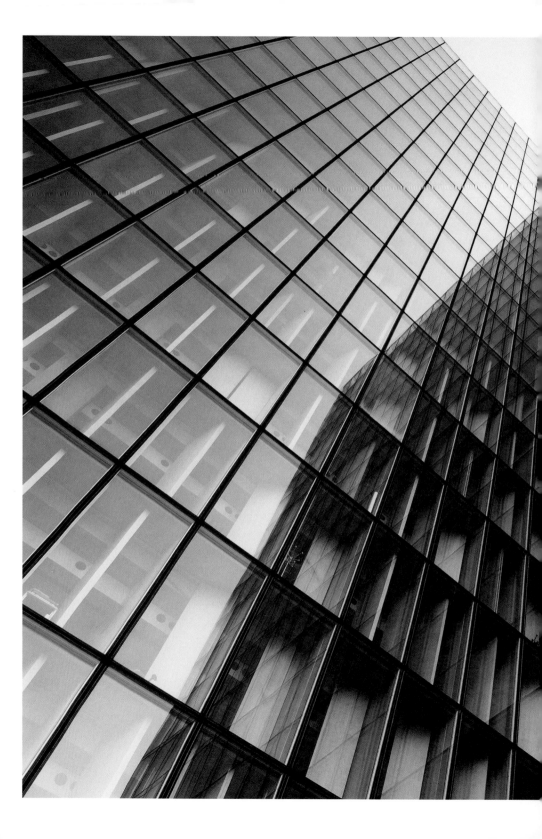

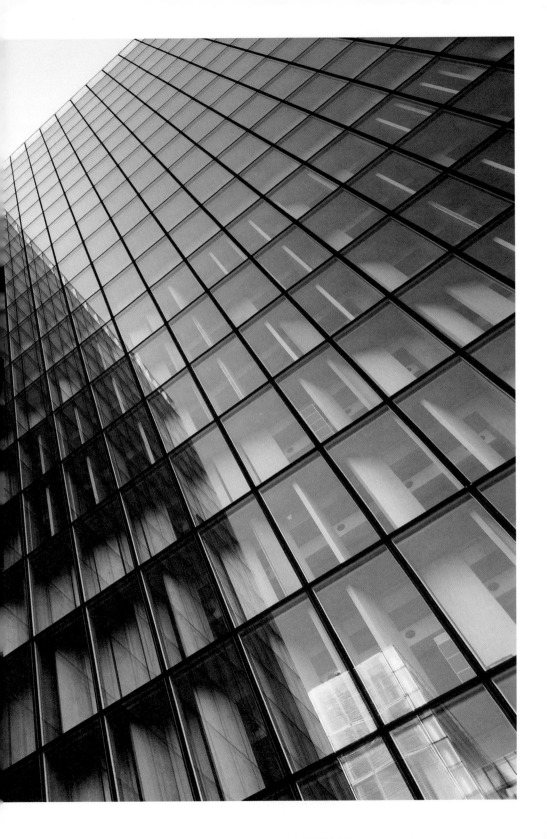

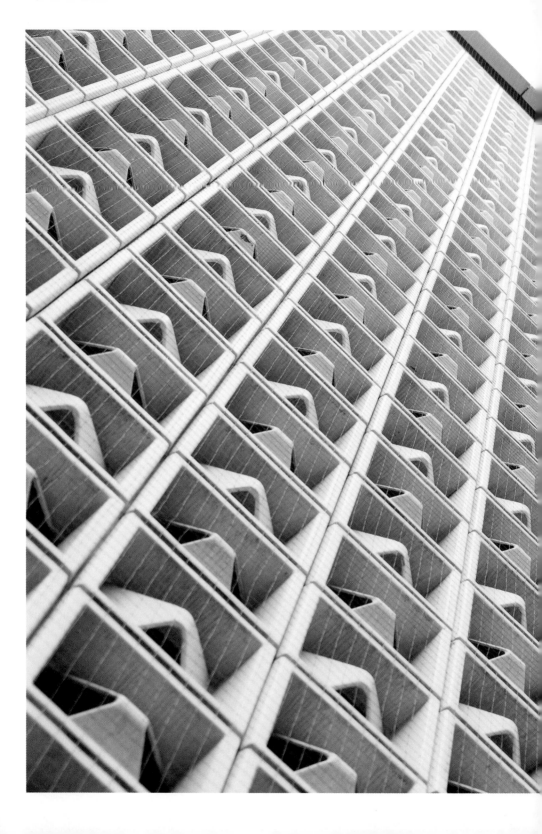

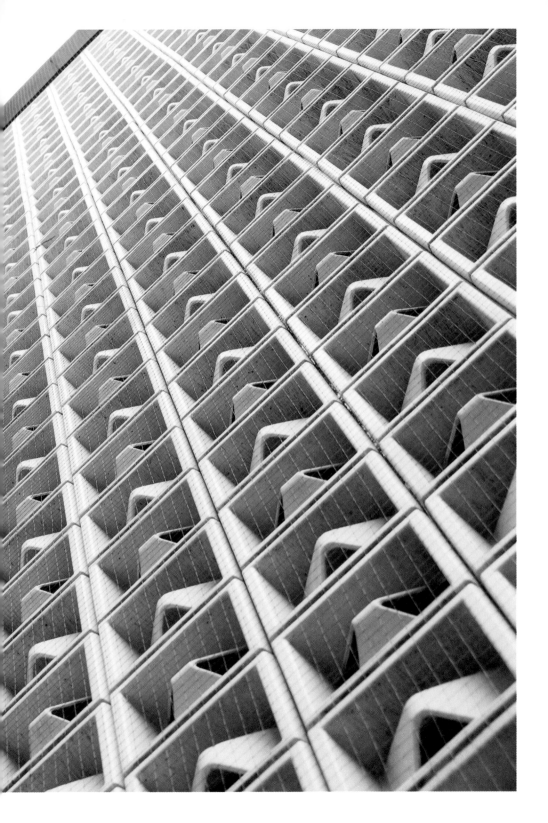

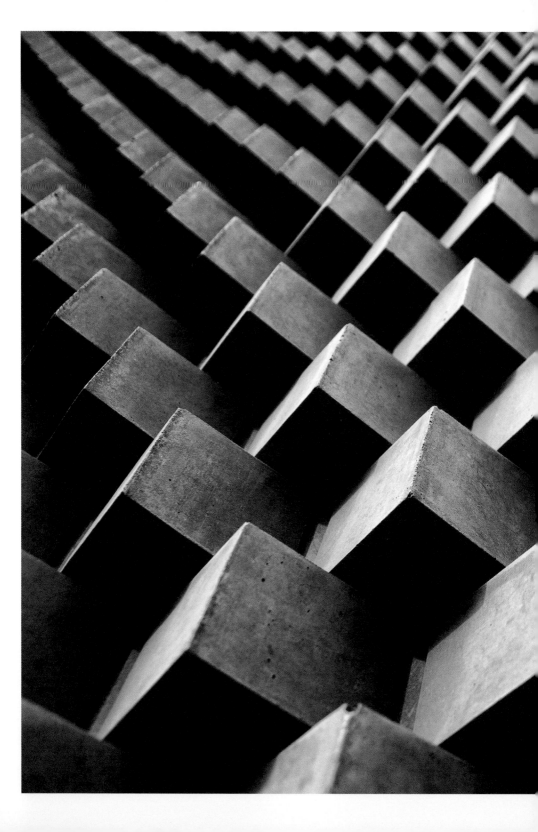

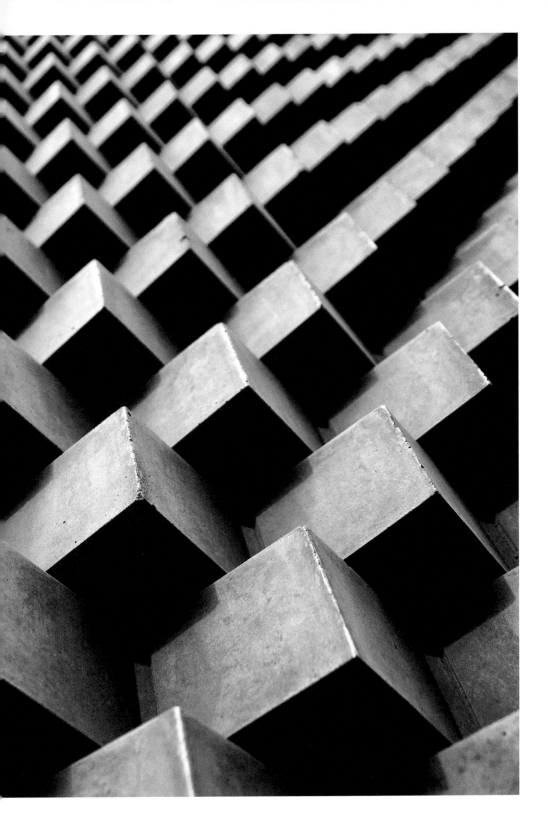

Tallinn, Estonia *(previous & opposite)*

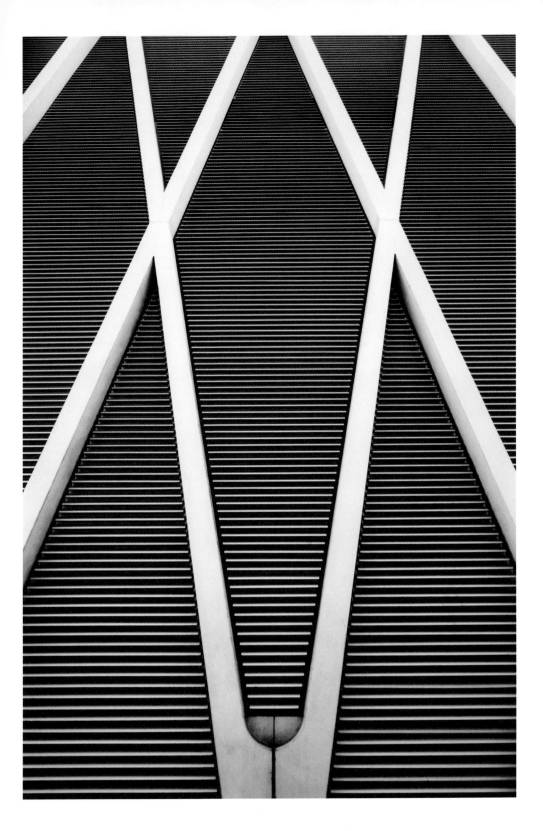

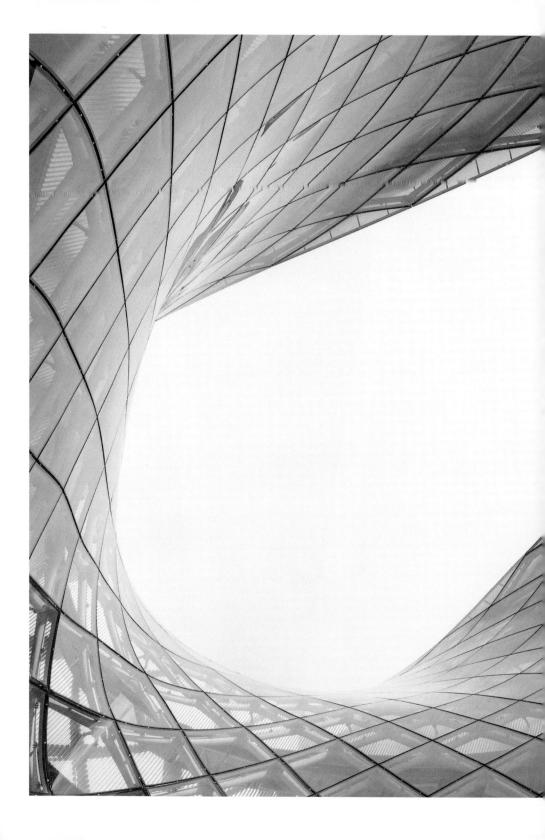

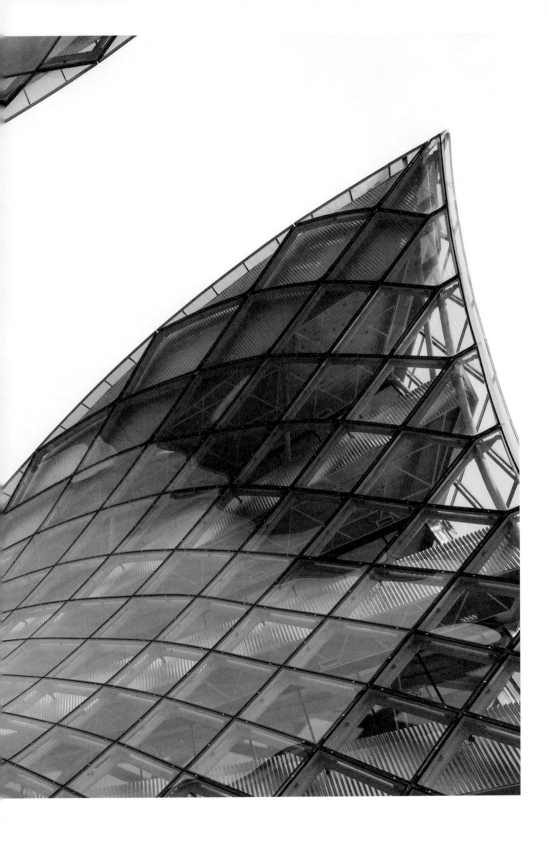

Malmö, Sweden *(previous)*
Seoul, South Korea *(opposite)*

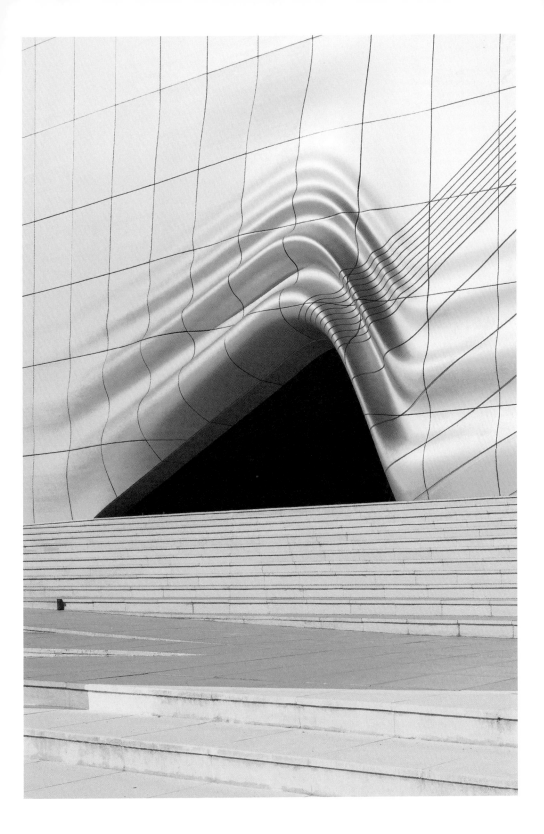

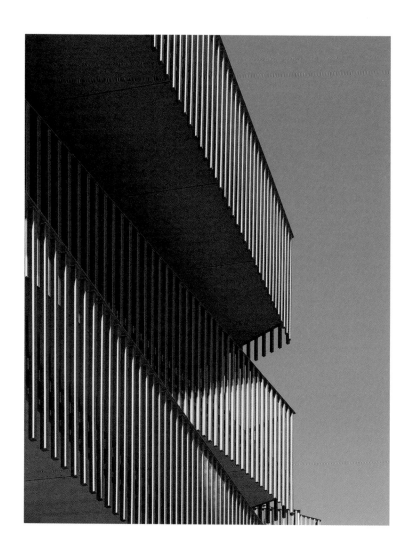

Tallinn, Estonia *(above & opposite)*
Bilbao, Spain *(overleaf)*

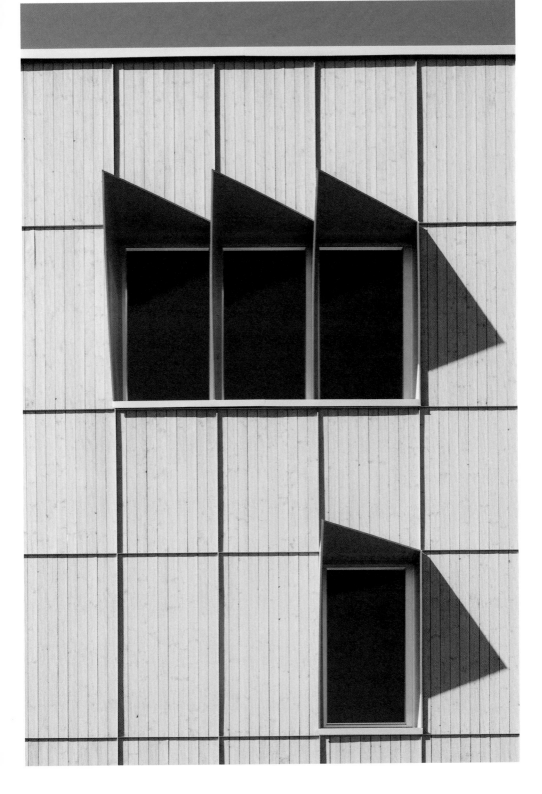

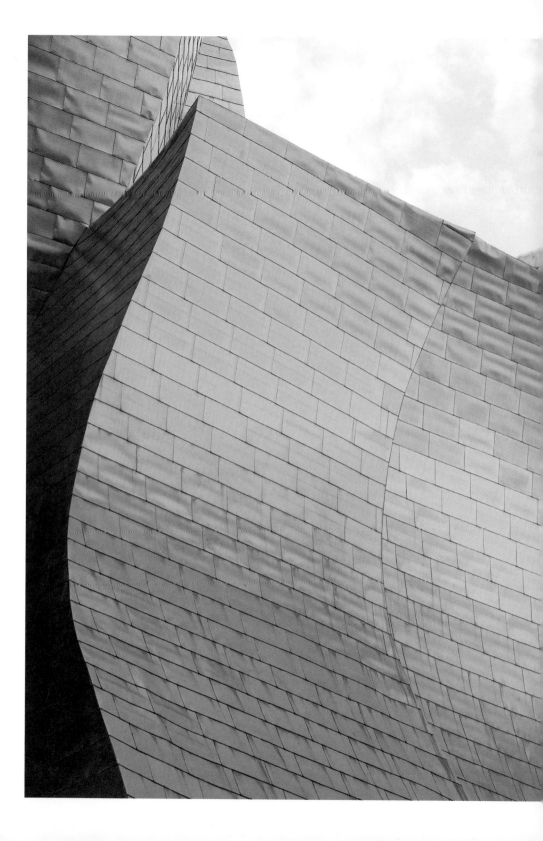

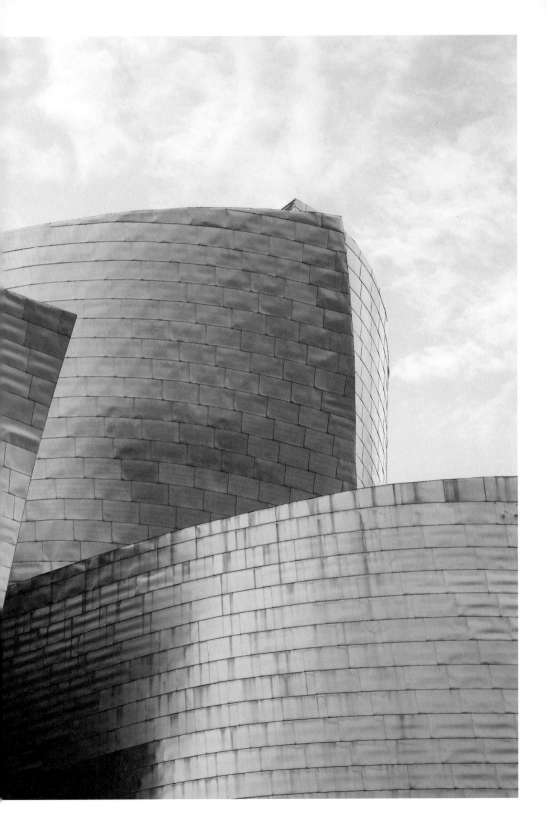

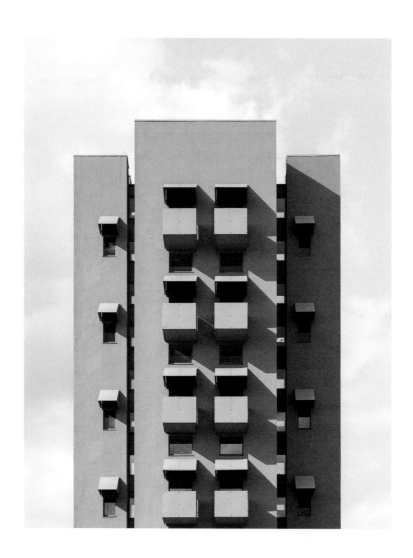

Berlin, Germany (*above*)

Huesca, Spain (*opposite*)

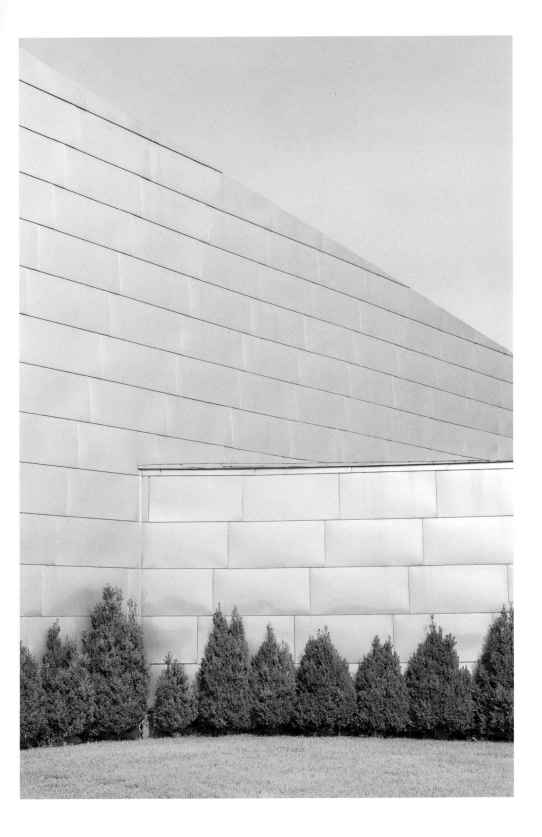

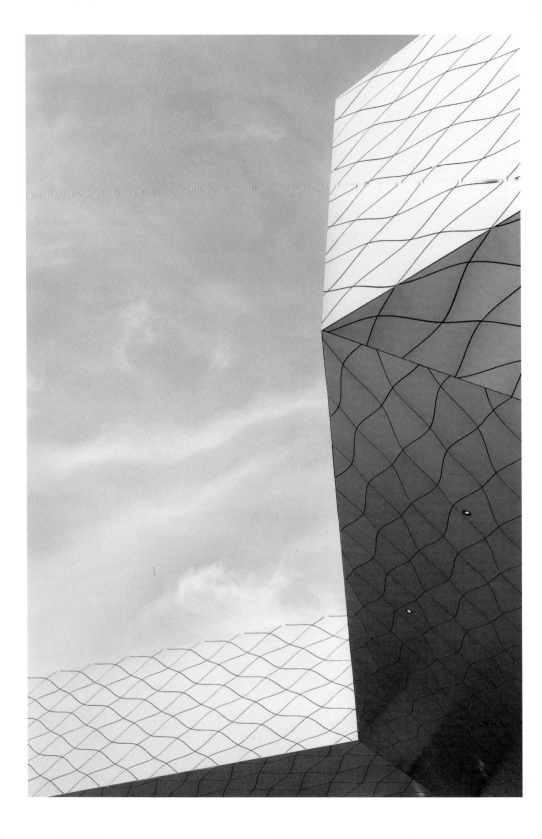

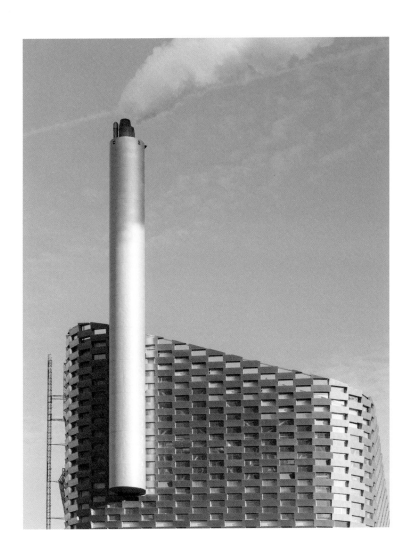

Copenhagen, Denmark *(above)*

Seoul, South Korea *(opposite)*

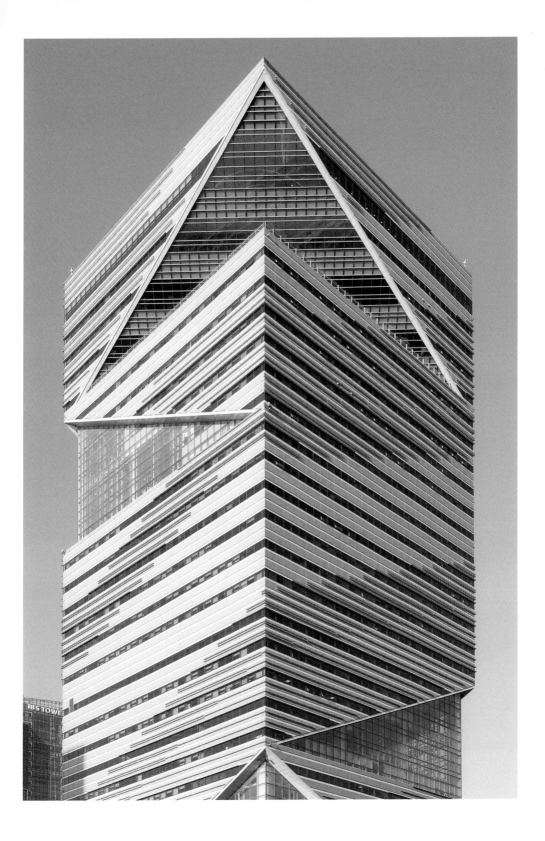

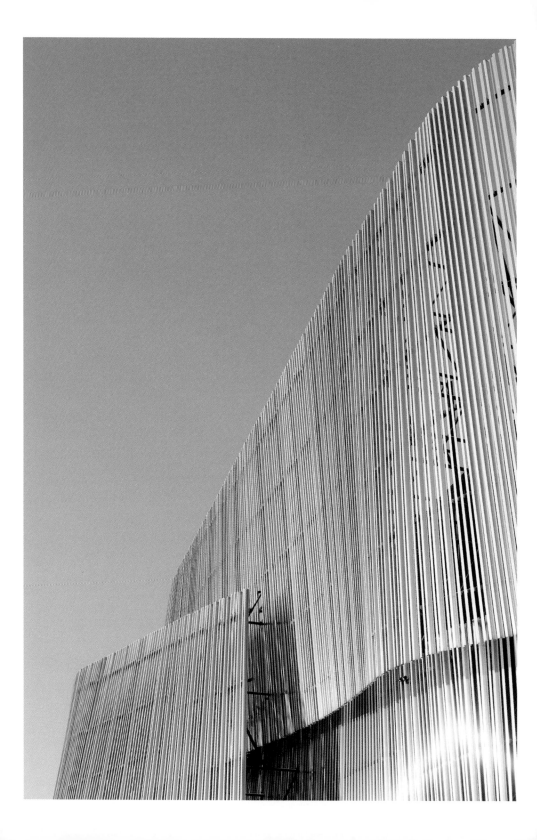

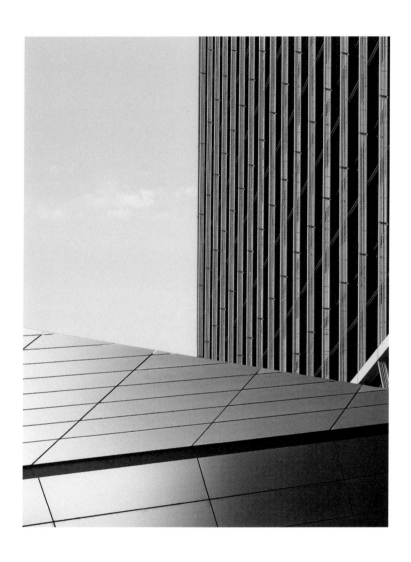

Taipei, Taiwan *(above)*

Stockholm, Sweden *(opposite)*

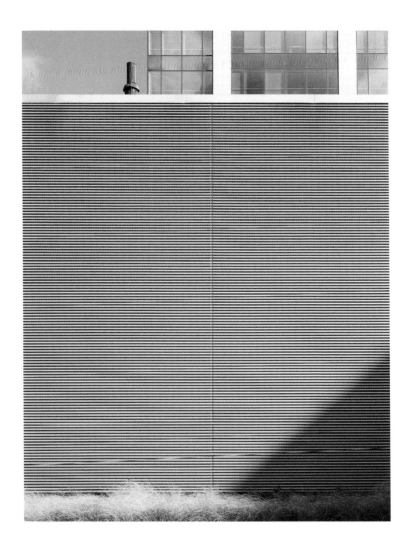

Brussels, Belgium *(above)*

Alicante, Spain *(opposite)*

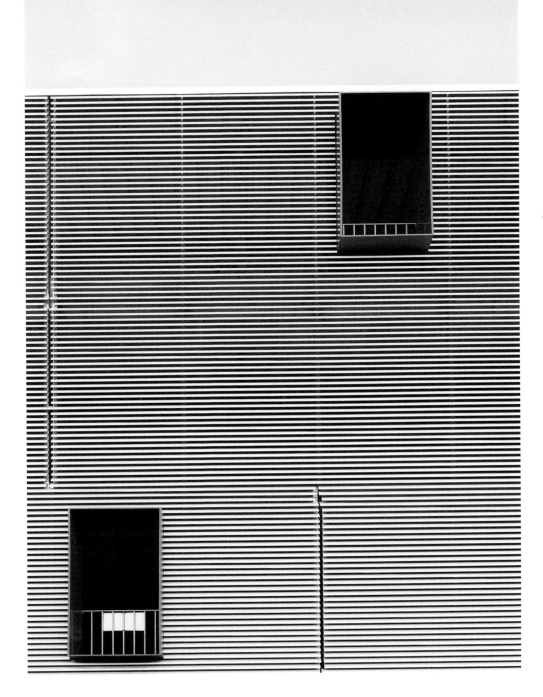

Copenhagen, Denmark *(opposite)*
Alicante, Spain *(overleaf)*

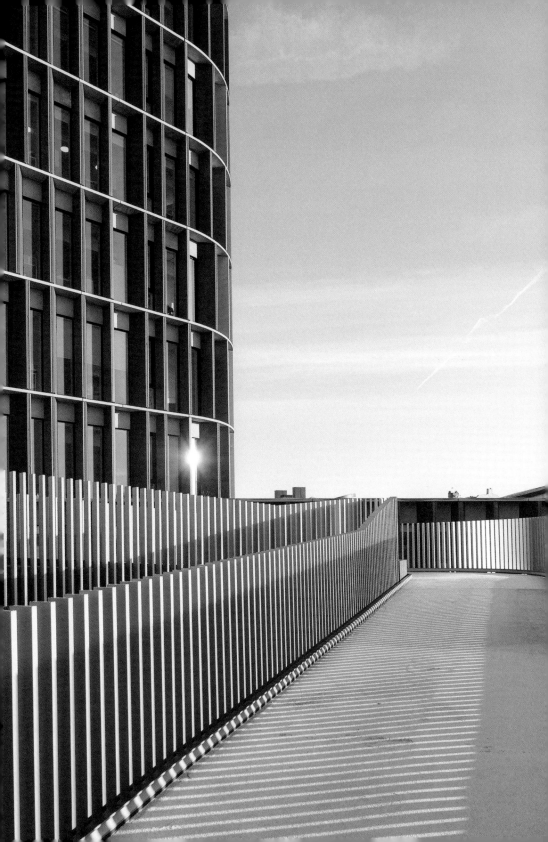

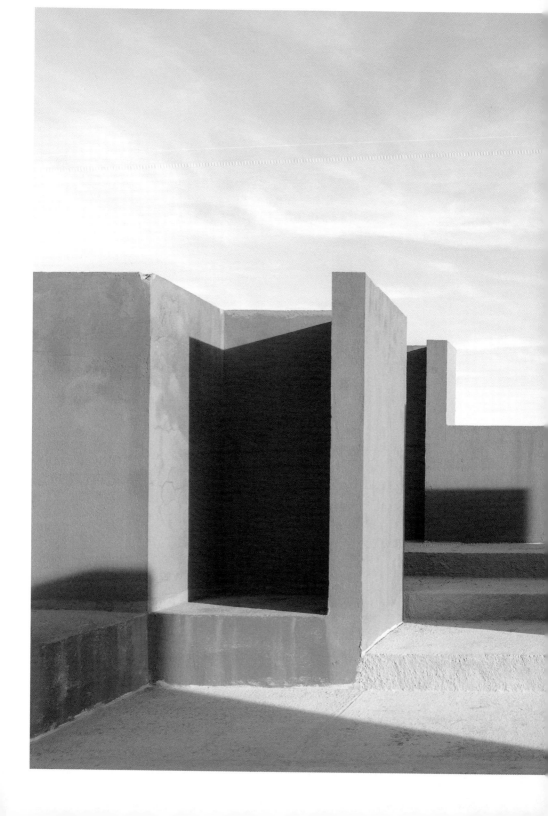

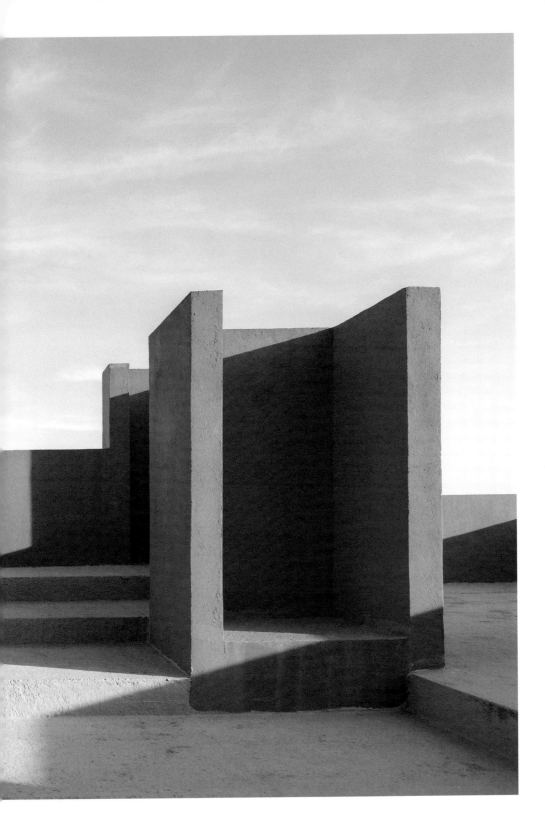

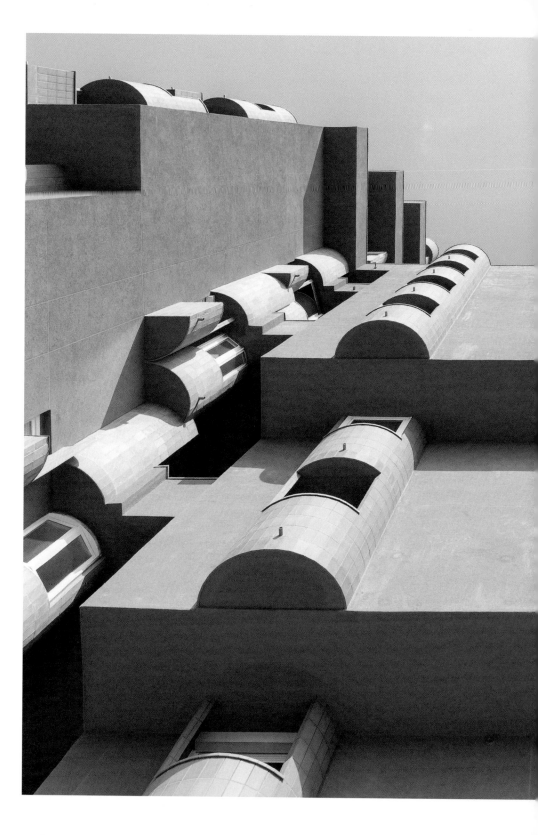

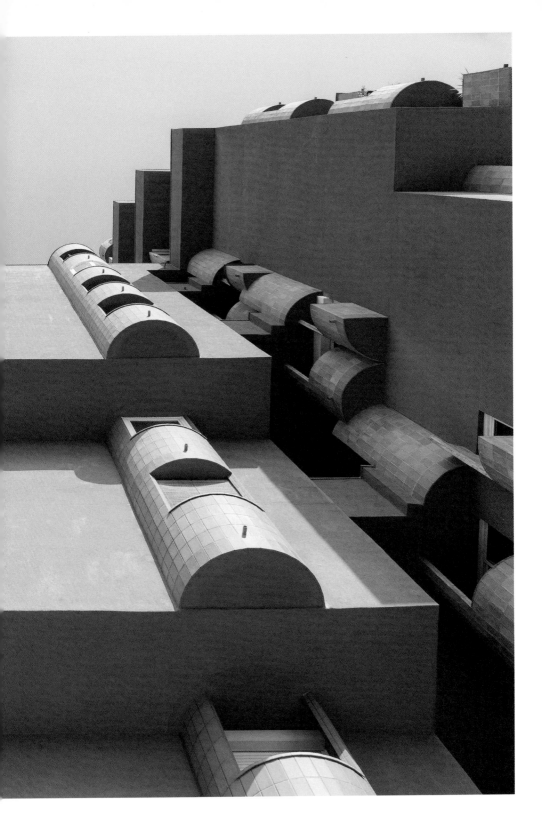

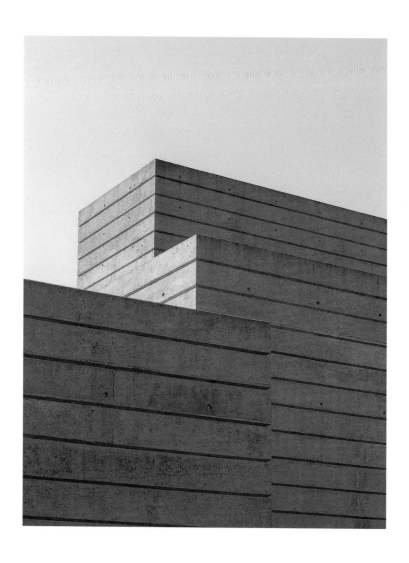

Barcelona, Spain *(previous)*
Huesca, Spain *(above)*
Taipei, Taiwan *(opposite)*

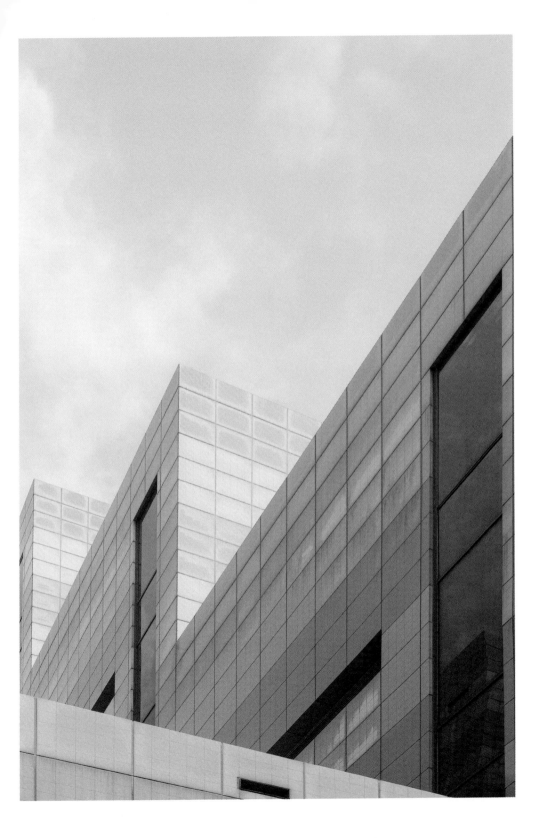

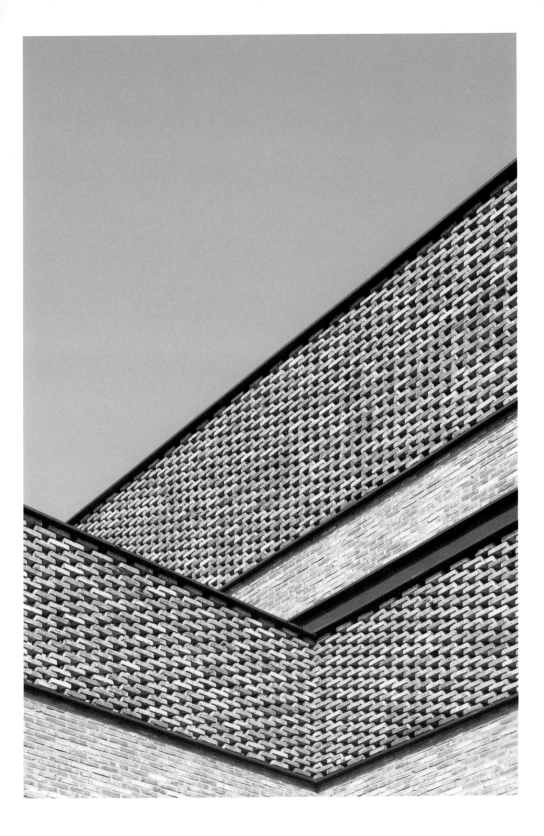

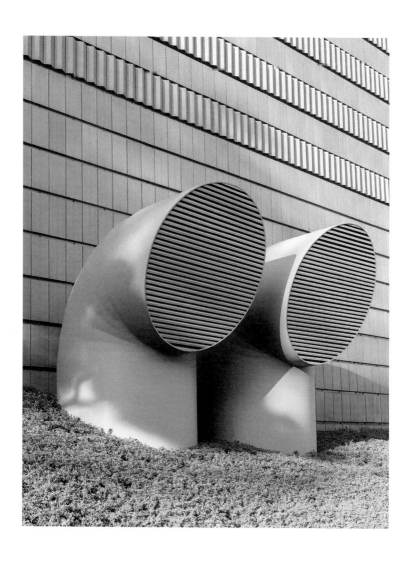

Seoul, South Korea (*above*)

84 Alicante, Spain (*opposite*)

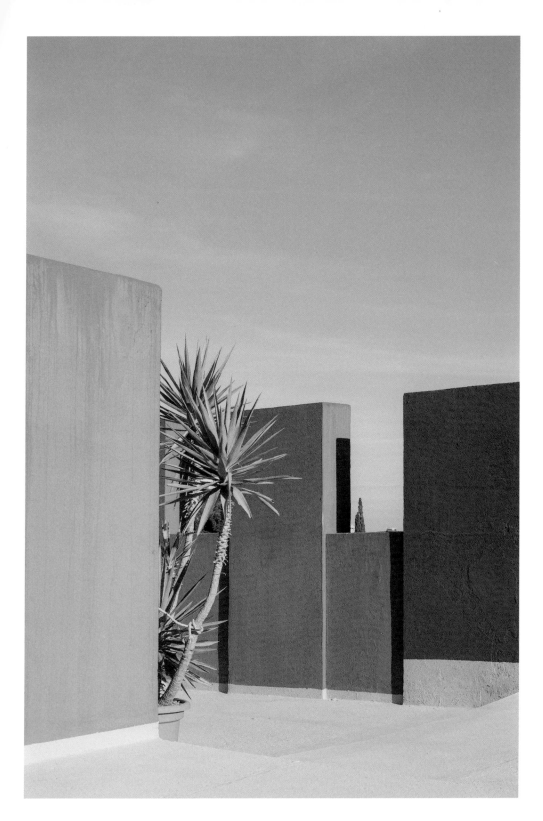

Stockholm, Sweden (*opposite*)

Milan, Italy (*overleaf*)

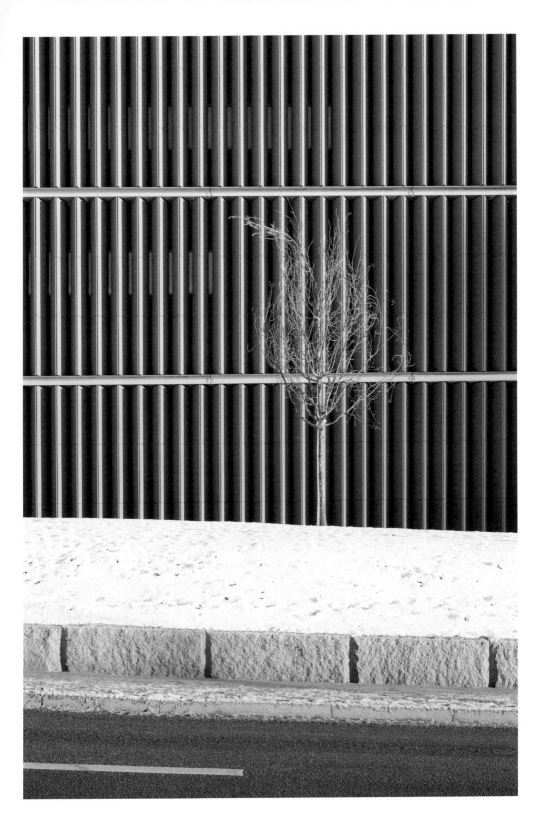

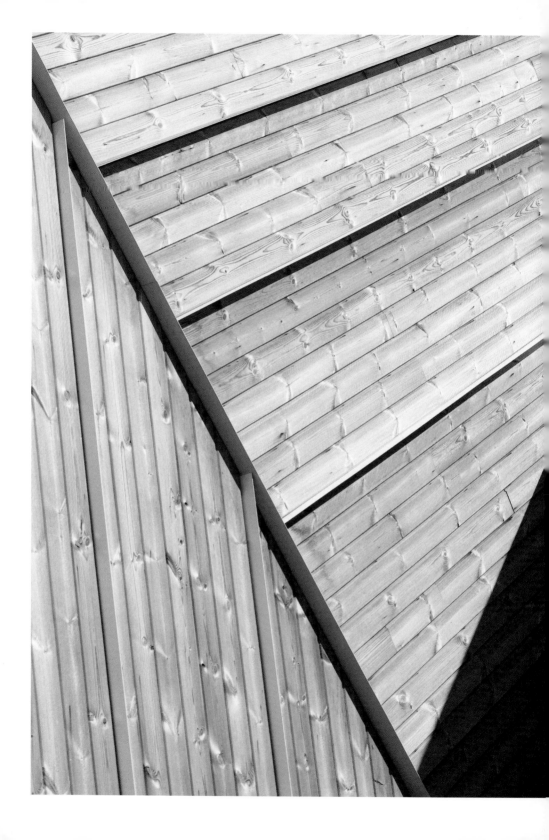

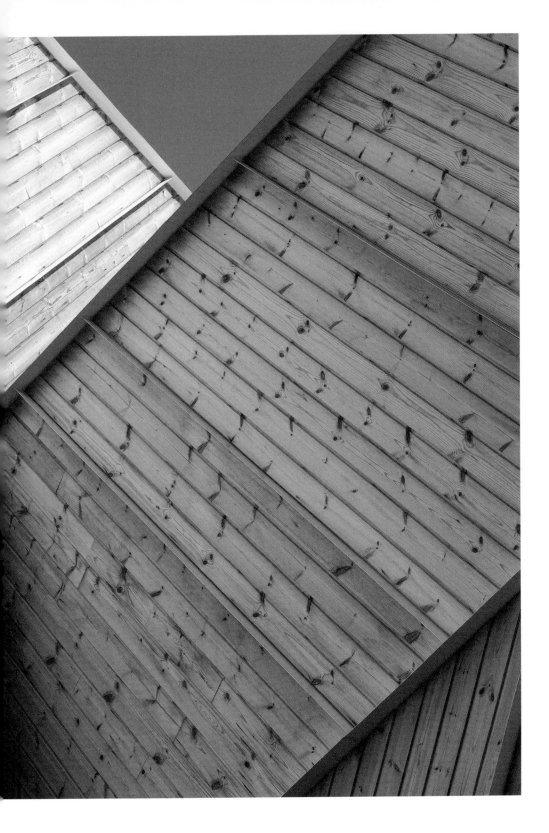

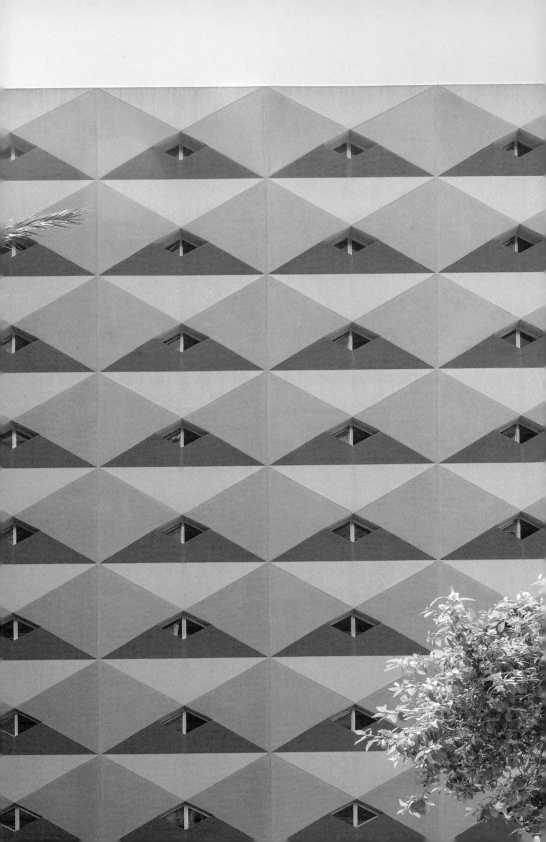

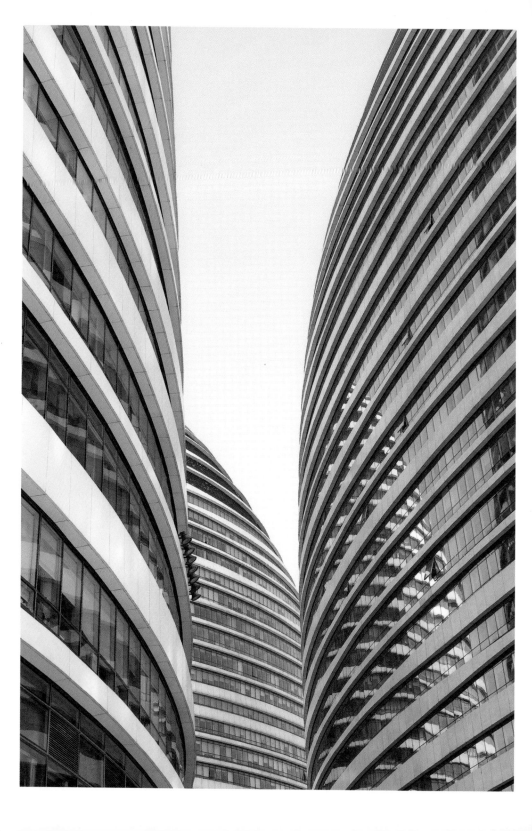

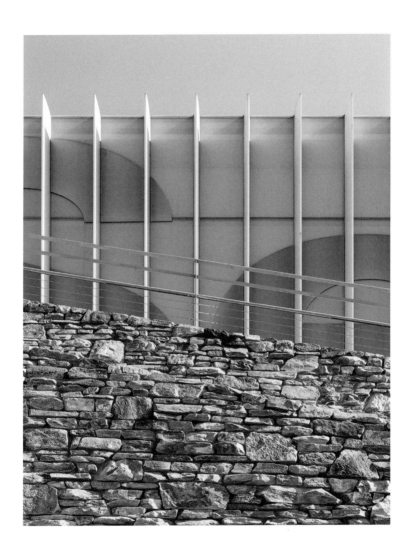

Seoul, South Korea *(above)*
Beijing, China *(opposite)*
Hamburg, Germany *(overleaf)*

93

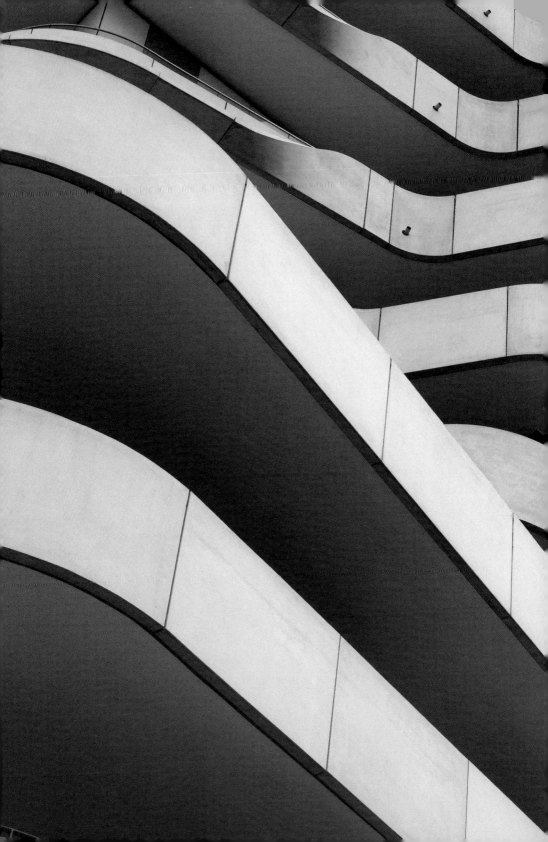

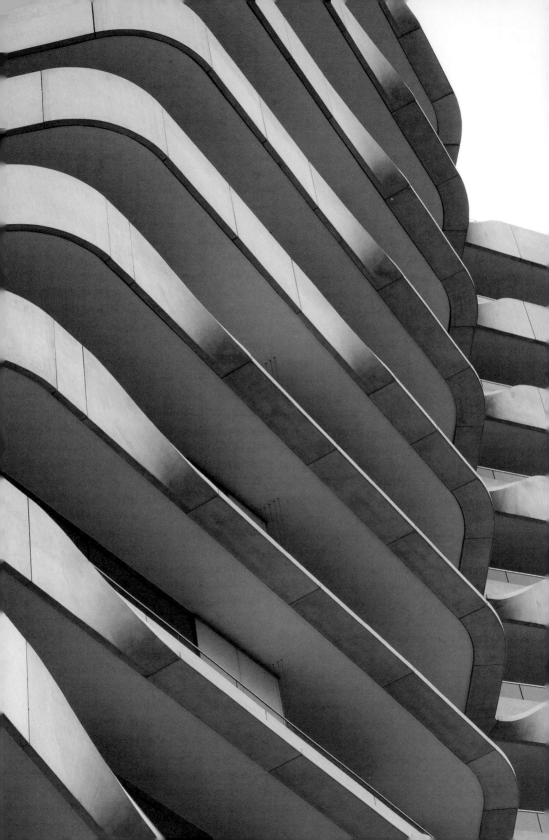

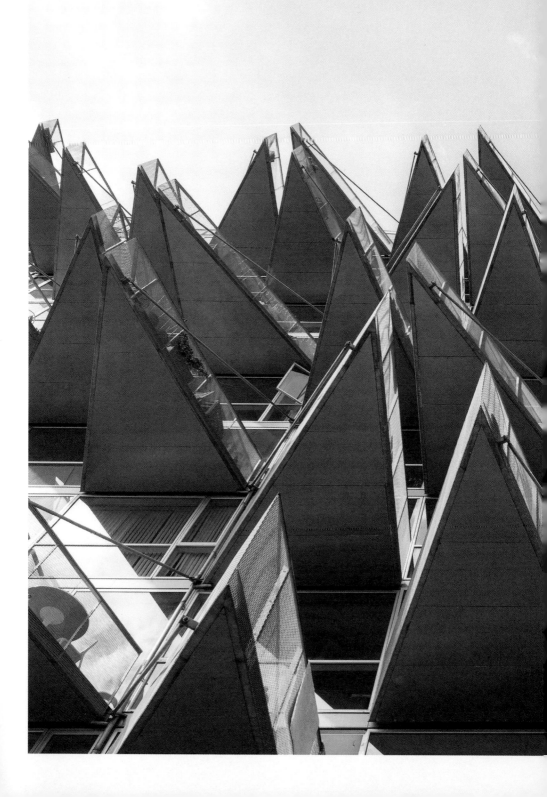

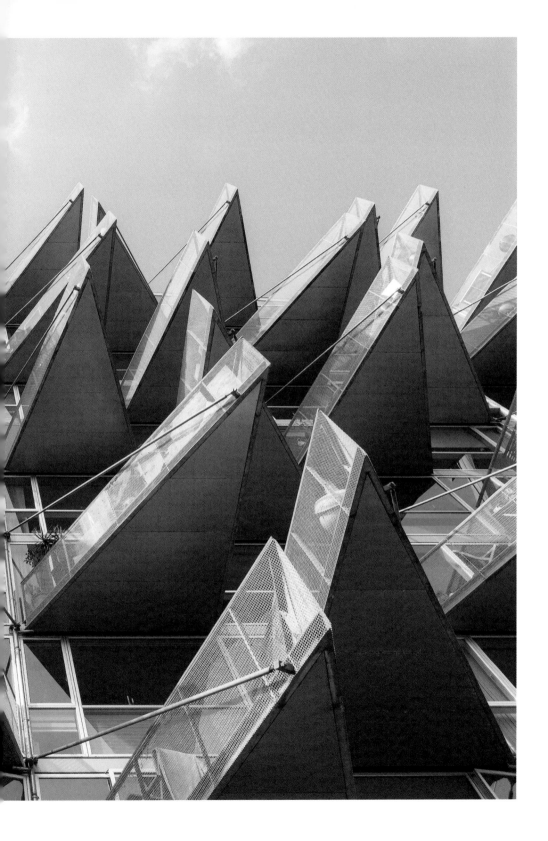

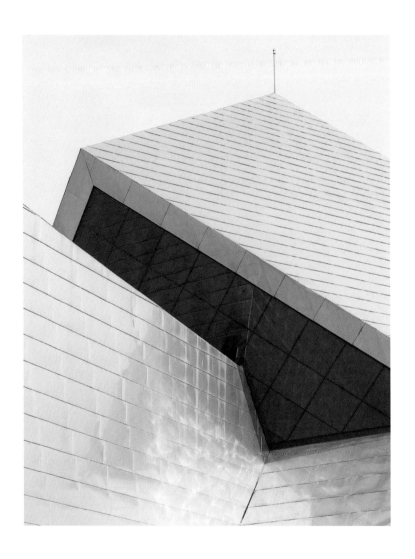

Copenhagen, Denmark *(previous)*
Huesca, Spain *(above)*
Milan, Italy *(opposite)*

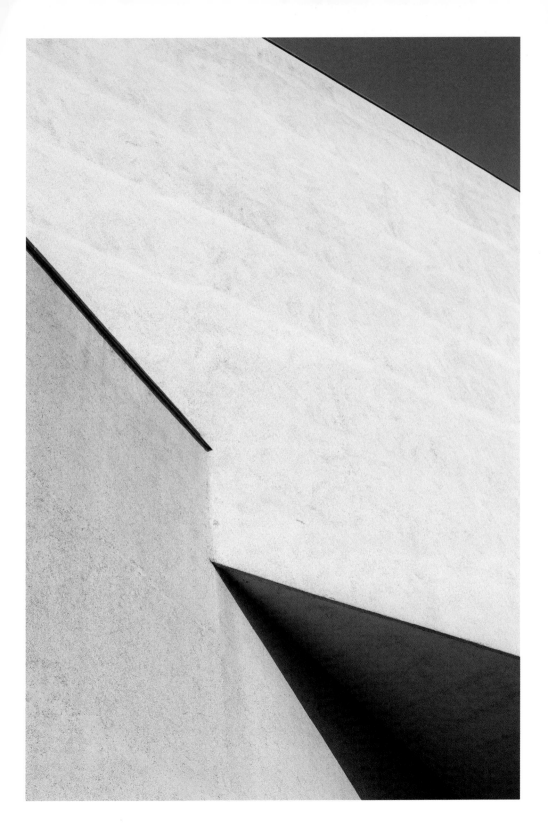

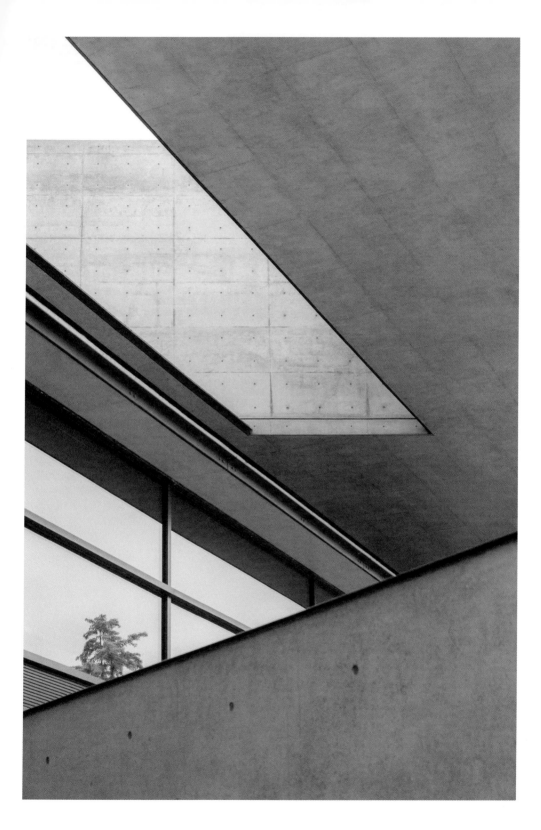

Tallinn, Estonia *(opposite)*

102 Seoul, South Korea *(overleaf)*

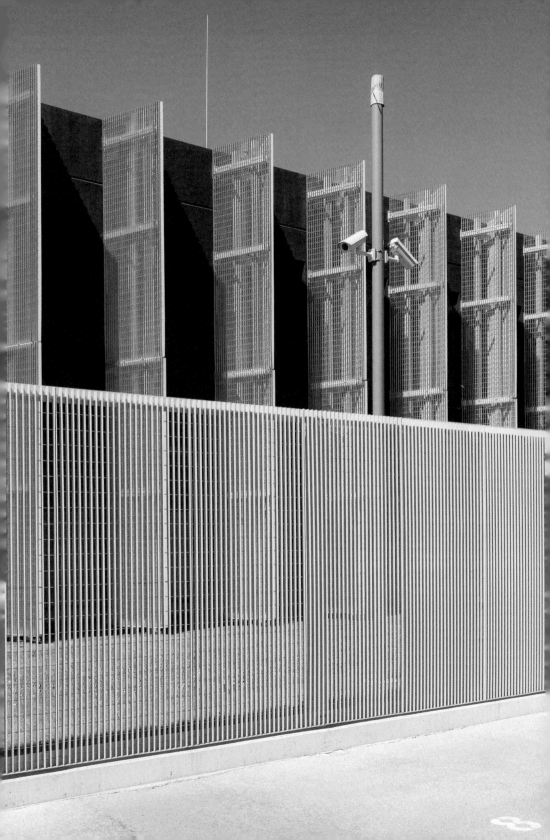

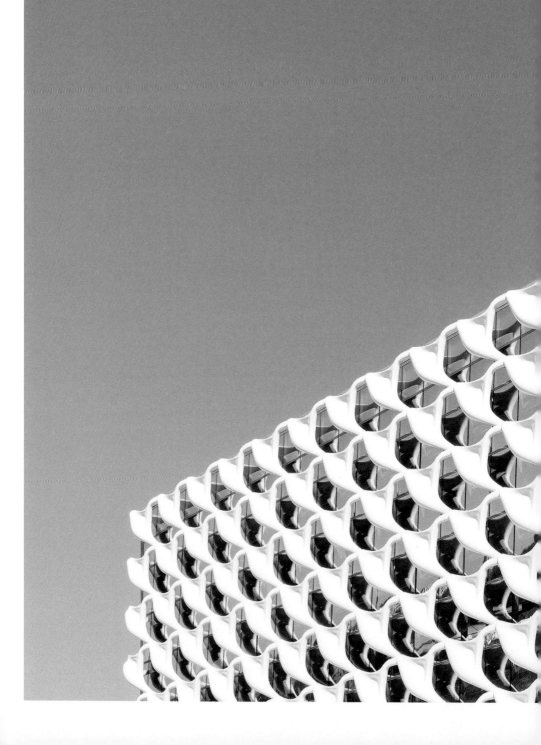

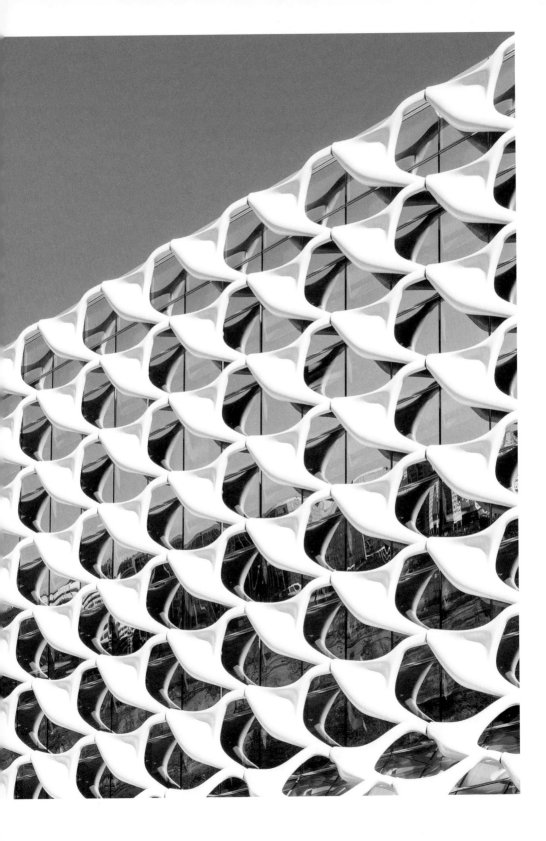

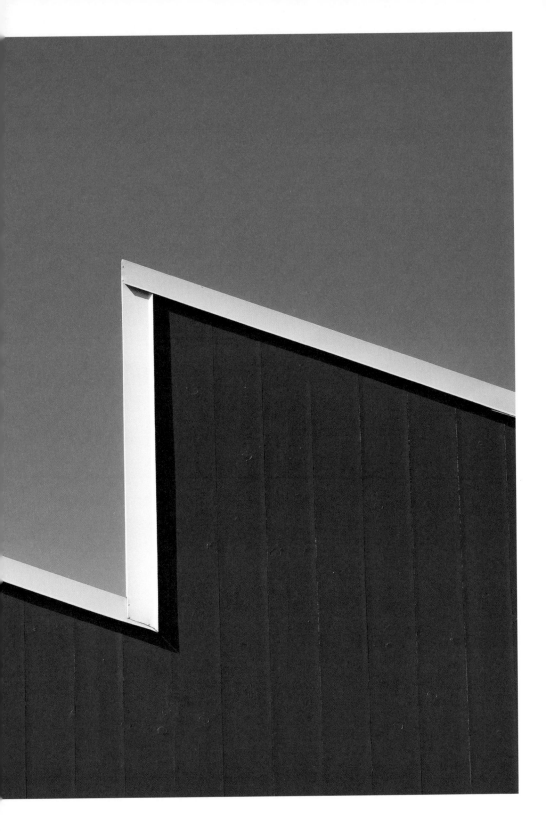

Milan, Italy *(previous)*
Harbin, China *(opposite)*

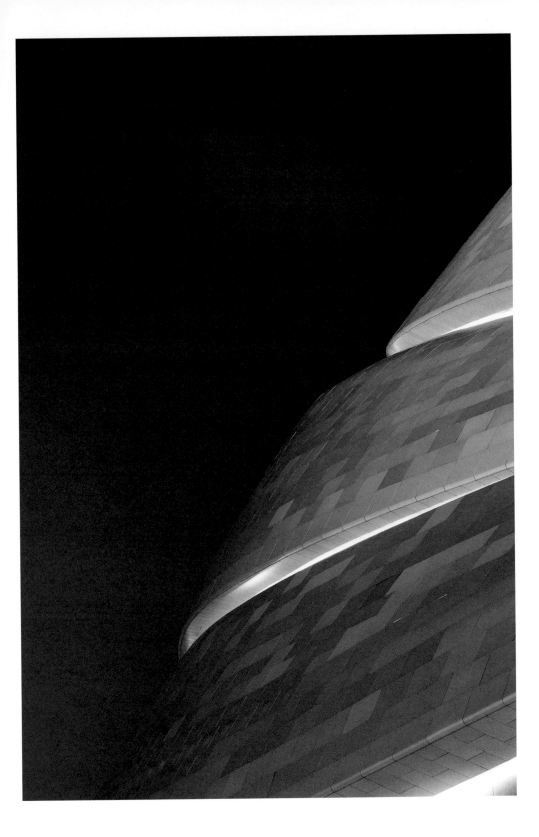

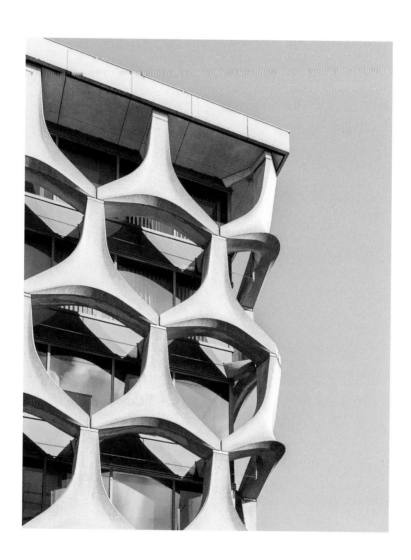

Brussels, Belgium *(above)*

Copenhagen, Denmark *(opposite)*

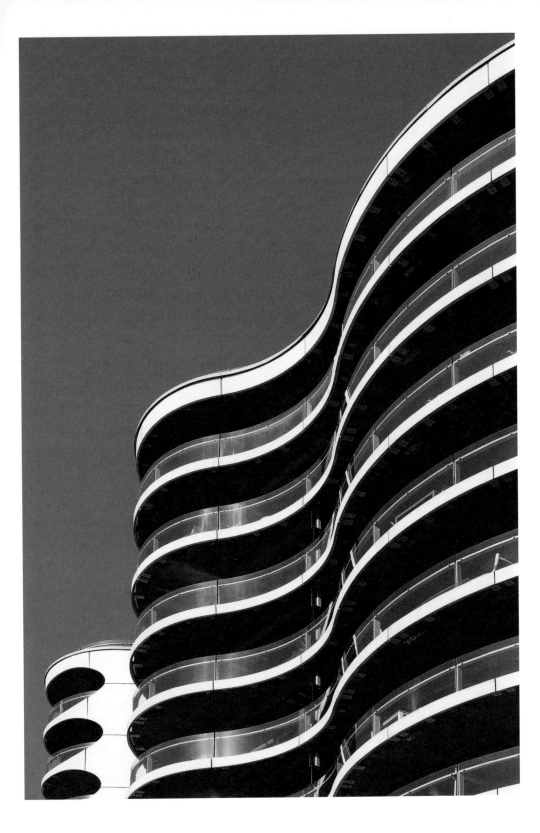

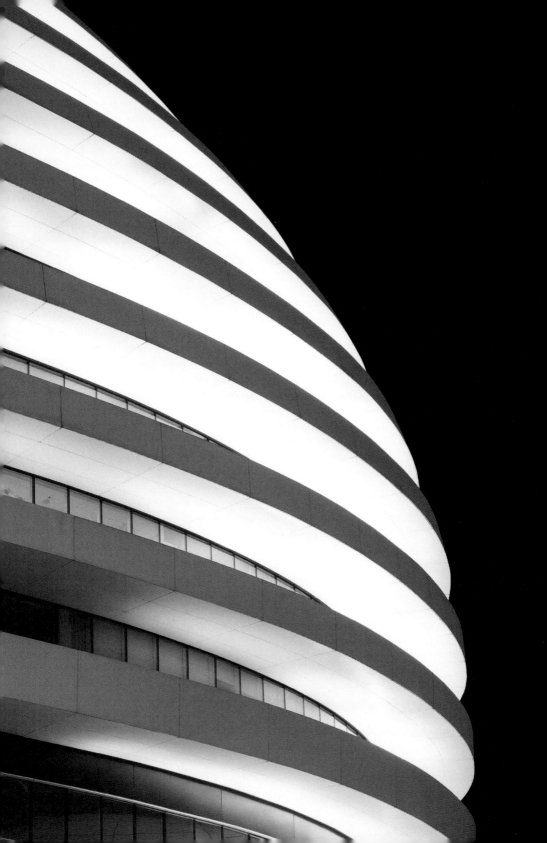

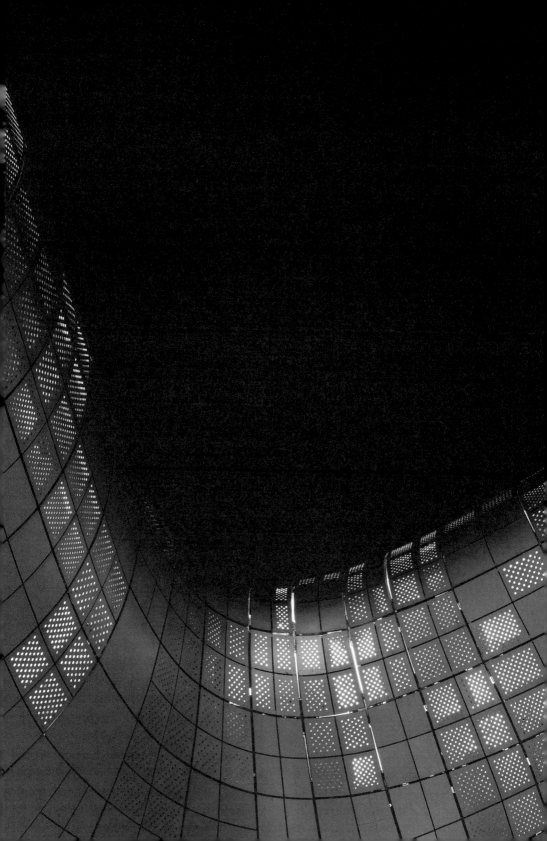

GLOSSARY

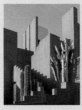 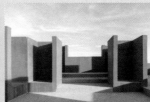 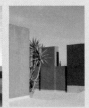

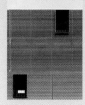
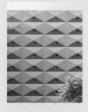
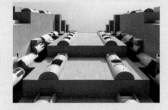
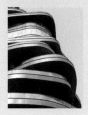
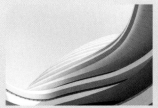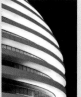
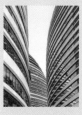

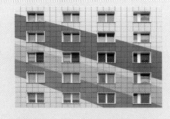
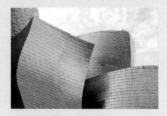
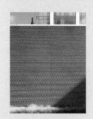
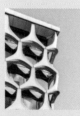
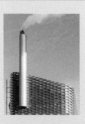

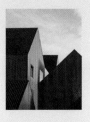

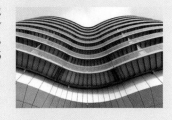

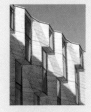

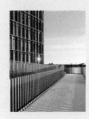

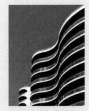

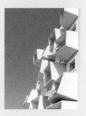

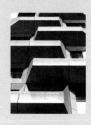
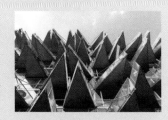
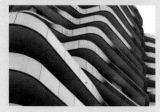
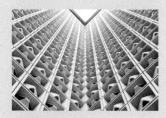
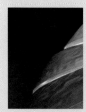
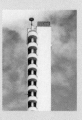

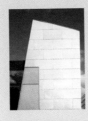
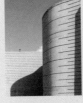 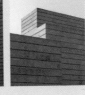
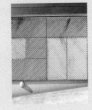
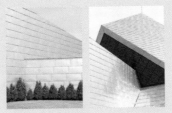
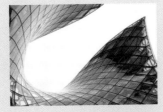
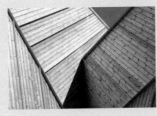

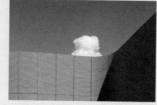
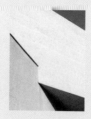
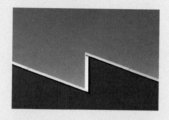
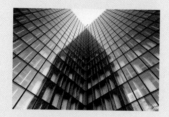
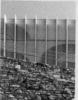

G TOWER
Architects: Haeahn Architects
Built: 2013
Photo: 2019

page 69

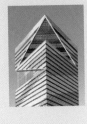

**HYUNDAI MOTORSTUDIO
GOYANG**
Architects: Delugan Meissl
Associated Architects
Built: 2017
Photo: 2019
page 66

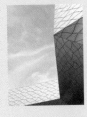

KIA BEAT 360
Architects: CA Plan
Built: 2017
Photo: 2019

page 25

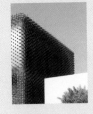

KOLON ONE & ONLY TOWER
Architects: Morphosis
Built: 2018
Photo: 2019

pages 104–105

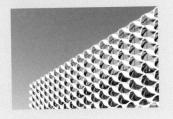

**LEEUM, SAMSUNG
MUSEUM OF ART**
Architects: Jean Nouvel ,
Rem Koolhaas
Built: 2004
Photo: 2019
page 84

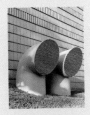

MIMESIS MUSEUM
Architects: Castanheira & Bastai
Arquitectos Associados + Jun Sung
Kim + Álvaro Siza Vieira
Built: 2009
Photo: 2018
page 11

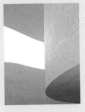

THE IMPRINT
Architects: MVRDV
Built: 2018
Photo: 2019

page 59

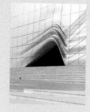

UNKNOWN BUILDING
Photo: 2018

pages 18–19

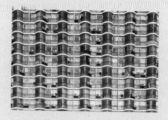

UNKNOWN BUILDING
Photo: 2019

page 83

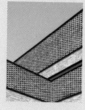

UNKNOWN BUILDING
Photo: 2018

page 37

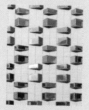

STOCKHOLM WATERFRONT
Architects: White Arkitekter
Built: 2010
Photo: 2020

page 70

STOCKHOLM

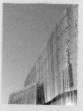

VÄRTAN BIOENERGY
CHP-PLANT
Architects: UD Urban Design AB +
Gottlieb Paludan Architects
Built: 2016
Photo: 2020
page 87

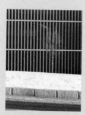

YOUTH HOUSING
Architects: Scheiwiller Svensson
Arkitektkontor
Built: 2012
Photo: 2020

pages 28–29

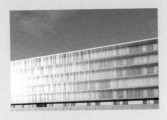

TAICHUNG

ASIA MUSEUM OF MODERN
ART, ASIA UNIVERSITY
Architects: Tadao Ando and Associates
Built: 2013
Photo: 2019

page 101

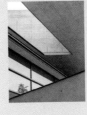

NATIONAL TAICHUNG
THEATRE
Architects: Toyo Ito & Associates
Built: 2016
Photo: 2019

page 13

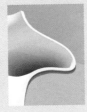

UNKNOWN BUILDING
(SCHOOL)
Photo: 2019

page 33

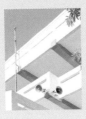

TAIPEI

TAO ZHU YIN YUAN
Architect: Vincent Callebaut
Built: 2019
Photo: 2019

page 42

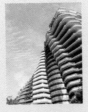

UNKNOWN BUILDING
Photo: 2019

page 71

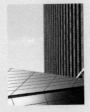

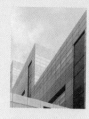
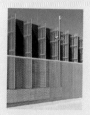
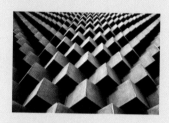
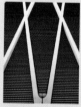
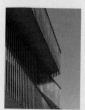
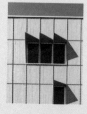

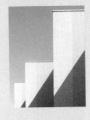
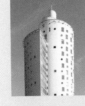

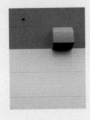

Urban Geometry

First edition

Published 2020 by
Hoxton Mini Press, London

Copyright © Hoxton Mini Press 2020. All rights reserved.

Photography by Andrés Gallardo Albajar
Design by Friederike Huber
Sequence by Friederike Huber and Andrés Gallardo Albajar
Copy-editing by Faith McAllister
Production by Anna De Pascale
Design support by Daniele Roa
Editorial support by Becca Jones
Introduction by Rachel Segal Hamilton

The rights of the authors to be identified as the creators of this Work have
been asserted under the Copyright, Designs and Patents Act 1988.

With thanks to our Kickstarter backers who invested in our future:

*Andrew, Laura and Raphael Beaumont, Anonymous, David Rix,
Don McConnell, Duncan, Liss and Theo, Fiona and Gordon (Bow),
Gareth Tennant, Gary, Graham McClelland, Herlinde, Jenifer Roberts,
Jennifer Barnaby, Joe Skade, Jonathan Crown, Jonathan J. N. Taylor,
Matt Jackson, Melissa O'Shaughnessy, Nigel S, Rob Phillips, Rory Cooper,
Simon Robinson and Steev A. Toth.*

No part of this publication may be reproduced, stored in a retrieval system,
or transmitted in any form or by any means, electronic, mechanical,
photocopying, recording or otherwise, without the prior written
permission of the copyright owner.

ISBN: 978-1-910566-83-1

A CIP catalogue record for this book is available from the British Library.
Printed and bound by Livonia, Latvia

To order books, collector's editions and signed prints please go to:
www.hoxtonminipress.com

MIX
Paper from
responsible sources
FSC
www.fsc.org FSC® C002795